Preface

SEVERAL years ago a graduate seminar at Yale University was presented with the problem of relating the artistic theory of Leon Battista Alberti to the artistic practice of fifteenth-century Florence. The only texts of Alberti's *Della pittura* available to the students were Janitschek's Italian edition and German translation of 1877 and Leoni's English translation of 1755. Comparison of both the German and English translations with the Italian text published by Janitschek indicated the need for a new critical English translation of *Della pittura*. This translation is concerned primarily with making such a text available to the student. As such it is only the first step towards a definitive edition of the original text and towards a fuller study of the relation of Alberti's theory to the practice of fifteenth-century Florentine painting.

The award of a Fulbright grant made it possible for me to spend 1951–2 in Italy examining and collating the known manuscripts of *Della pittura*. By this means Alberti's original intention in his treatise began to emerge from the additions of critics and translators. At the same time the most accurate readings and the amount and kind of variants between the Latin and Italian versions of the text were more readily determined. The following translation, then, is based first on the extant manuscripts, secondly on a hypothetical text that

7

attempts to approach the original text as closely as possible. The notes have been restricted to those which identify or clarify. As a result they diminish in frequency as the reader's knowledge of the text becomes greater and as Alberti moves into less complex problems.

I should like to express my especial gratitude to the members of the Fulbright Commission who made a year in Italy both possible and profitable. To Bernard Berenson, who has received the gratitude of so many art historians, I add my own thanks. By generously placing his library and 'fototeca' at my disposal he facilitated this study; by his advice, criticism and interest he encouraged it. To my colleague, Mr. John Pancoast, I express my appreciation for discussions of the problems of the translation and for material aid in the form of photographs and ideas. To Professor Thomas G. Bergin of Yale University goes my gratitude for aid in unravelling some of the more complicated passages and for reviewing the accuracy of the translation. I offer my appreciation for helpful indications to Professor Richard Krautheimer of New York University and Professor Clarence Kennedy of Smith College. To Professor Charles Seymour, junr., go my thanks for guidance of this work both at Yale and abroad. My thanks are also due for various permissions, including those of photography, to the following: Vatican Library, Biblioteca Nazionale and Biblioteca Riccardi in Florence, the Bibliothèque Nationale in Paris, and the Library of the University of North Carolina. Mary Helen Ward deserves the credit and my thanks for the Index.

JOHN R. SPENCER
Yale University
1956

ON PAINTING

LEON BATTISTA ALBERTI

On Painting

TRANSLATED WITH INTRODUCTION AND NOTES BY
JOHN R. SPENCER

NEW HAVEN AND LONDON | YALE UNIVERSITY PRESS

First published in the United States in 1956
by the Yale University Press,
New Haven, Connecticut.

Revised edition 1966.

Printed in the United States of America

06 07 08 15 14 13 12 11 10

ISBN: 0-300-00001-4 (paper)

ORIGINALLY PUBLISHED ON THE LOUIS STERN MEMORIAL FUND

To
P.A.B.S.

Contents

	Page
PREFACE	7
PREFACE TO THE SECOND IMPRESSION	9
INTRODUCTION	11
SOURCES	33
NOTES TO INTRODUCTION	37
PROLOGUE	39
BOOK ONE	43
BOOK TWO	63
BOOK THREE	89
NOTES TO TEXT	99
INDEX	137

Preface to the Second Impression

IN this second impression I have attempted only to correct the major errors and to make minor improvements in the translation. There are always any number of passages to improve, for a translation is never finished. I hope that I have been able to raise my hand from the work at the right moment and to avoid the extremes of quickness of execution and of overworking so sharply criticized by Alberti in his treatise.

The introduction is already long enough, but it should be expanded to treat more fully the implications of Alberti's *istoria* and of Books II and III for the history of Italian Renaissance painting. The thoughtful reader will find recent bibliography in the notes to assist him in drawing his own conclusions. My other statements remain much the same. The Italian version of this treatise is out of print and unobtainable; the Latin version remains to be done. I am even more persuaded today of Alberti's importance for the study of fifteenth-century Italian art than I was when I first read this little book as a beginning graduate student.

J. S.
Oberlin College
January 1966

Introduction

Leon Battista Alberti's *Della pittura* is the first modern treatise on the theory of painting. Although it appeared at a moment—1435-6—when the old and the new order in art were still existing side by side in Florence, it broke with the Middle Ages and pointed the way to the modern era. While Cennino Cennini's almost contemporary *Libro dell'arte* summed up preceding medieval practice, *Della pittura* prepared the way for the art, the artist, and the patron of the Renaissance. As a result the art of painting was given a new direction which made a return to the Middle Ages all but impossible. The practice of painting both within and outside Florence fell rapidly under the influence of concepts advanced in the treatise. Alberti's own Italian translation from his Latin original probably entered the shops as something of an 'inspirational handbook' and became so popular that it was read out of existence. By the sixteenth century the Italian version was unknown,[1] while today there are only two extant Italian manuscripts compared to six in Latin. Although the art Alberti advocates is based on training acquired under a master and apprentice system, it gives the artist and his art the means of breaking away from such a system to attain the individualism familiar since the High Renaissance. In this respect *Della pittura* is intimately bound up with the moment which produced it, a period of

transition in Florentine art when the new was slowly making its way against the old. Alberti's overstatements and his sharp criticism of former practice reflect the tensions of his time, yet he never loses his assurance of final victory or his optimism for the future.

As art theory *Della pittura* became one of the chief sources for later treatises on the art of painting. In the fifteenth century Filarete, Piero della Francesca and Leonardo drew from it many of the concepts which appear in their writing. From the *editio princeps* published in Basle in 1540 to the present time the work has gone through more translations and re-editions than Alberti's *De re aedificatoria* and only slightly fewer than his more generally popular *Della famiglia*. At each appearance of the text it has been taken up by art theorists of the moment and woven into their own concepts of the art of painting. The Basle edition in Latin was followed in 1547 by Lodovico Domenichi's Italian translation published in Venice. Vasari's emphasis on theory in the prefaces of his *Lives* reflects this reawakened interest in the treatise. The DuFresne translation of 1651 in Paris became the basis for much of Félibien's *Entretiens* in which Alberti is evoked as an 'authority' for French academic practice. *Della pittura* was not made generally available in England until Leoni brought out four English translations between 1726 and 1755; their effect on Hogarth, Reynolds and the Royal Academy is quite clear.

Perhaps the academies were too strongly attracted to Alberti's treatise. Certainly their interpretation of it has damaged its current reputation. Academic painters from the late sixteenth through the eighteenth centuries were searching for a rational art which allowed no place for fantasy. In such an art the solid virtues of diligence and application advocated by Alberti take on greater importance than the bravura of genius. The academies saw in *Della pittura* the means to fill their needs. In their hands Alberti's suggestions become rigid rules; his concepts of reason, verisimilitude, and dignity are exaggerated out

of proportion. Unfortunately, many critics still regard *Della pittura* as the source of seventeenth- and eighteenth-century academic practice. Alberti's suggestions of drawing from sculpture do not necessarily refer to plaster casts of the antique, nor can his concept of *istoria* be limited strictly to narrative or historical painting. *Della pittura* must first be considered as a document of and for the art of fifteenth-century Florence, without the accretions of succeeding centuries.

The surprise which Alberti expresses in his Italian dedication at seeing the new Florence on his return 'from the long exile in which we Alberti have grown old into this our city adorned above all others'[2] is only partly literary. Although he may have briefly visited Florence late in 1428 when the ban against the Alberti was partially raised, this statement is the first indication of his return to the city of his forebears. Beginning in 1387 with the exile of Leon Battista's grandfather, Benedetto, the head of the Alberti family, the Albizzi faction had succeeded by 1412 in expelling all but one Alberti from Florence. Leon Battista's father, Lorenzo, was banished from the city in 1401. Like other members of the family he transferred his activities to a city with an important branch of the Alberti banks. In Genoa a noble Bolognese widow bore him two sons, Carlo in 1403 and Battista in 1404. Lorenzo's childless marriage in 1408 to a Florentine woman has caused confusion as to the place and date of Alberti's birth until the recent discovery of a document which identifies his mother and the year of his birth.[3] By 1410 Lorenzo Alberti was established in Venice and Padua, and the young Battista was probably entered in the school of the humanist Gasparino Barzizza at Padua. In 1421 he had already enrolled in canon and civil law at the University of Bologna. Perhaps by 1424–5 new interests led him to the study of philosophy and the natural sciences. Although the decade preceding Alberti's appointment as *abbreviatore apostolico* in 1431 is probably the least documented

period in his life, the nature of these formative years can be deduced from his writings. The increasing frequency of references to Greek and Roman authors, together with essays and a play based on Roman models, indicate his rapid assimilation of the newly discovered literature of antiquity. It is characteristic of Alberti that he was not merely a receptacle for knowledge. As his mind opened under the influence of the literature of the past, he felt a need to incorporate his own thinking with that of the ancients in the form of essays and letters. Alberti was apparently not so stimulated by his travels as he was by study and writing. References to the lime used in mortar in France and Bruges[4] are the only indications that he may have accompanied Cardinal Nicholas Albergati on the peace mission of 1431 that attempted to end the Hundred Years War.

By 1434 Alberti's literary and philosophical knowledge probably compared well with that of any young humanist. His artistic knowledge may have been limited to a reasonable understanding of the art of northern Italy, an acquaintance with the art of France and the Low Countries, and a lively interest in Roman antiquity aroused by his attachment to the Curia in Rome from 1431. With such a background Alberti could not fail to be astounded on entering Florence with the suite of Pope Eugene IV in 1434. Brunelleschi was just closing the dome of the Cathedral, while the Sagrestia Vecchia of S. Lorenzo was finished and the nave of the church probably was well under construction. Donatello had completed much of his sculpture for the façade of the cathedral and the niches of Or San Michele and had begun work on his Cantoria. Ghiberti's first doors for the Baptistry were already in place and the second doors were in progress. Both Masaccio and Nanni di Banco were dead but their works were still fresh and new in Florence. Alberti had stepped into an artistic revolution. Its powerful and instantaneous impact is felt throughout *Della pittura* and lingers on in the much later *De re aedificatoria*.[5]

Alberti's enthusiasm and his optimism for the accomplish-

ments of the new age continued throughout his life. His energies were rarely directed towards uncovering new knowledge for a restricted group of fellow humanists, but rather towards making the knowledge acquired by the humanists available to a wider audience. In the ameliorative sense of the word, he was a popularizer. *Della pittura* partakes of this tendency in Alberti's work. His aim in this treatise is one of making the new humanist art of Florence understandable and desirable for a larger group of artists and patrons. Like many of his other works, *Della pittura* is not based solely on citations drawn from antique texts. Greek and Roman authors are used to give variety to the subject matter and to establish precedents for the suggestions advanced. The real basis for all of Alberti's writings lies in practice. *Della pittura* is built on the means, the aims and the results of the art of Brunelleschi, Donatello and Masaccio. At the same time Alberti was not wholly ignorant of the actual problems confronting the artist. Although we would perhaps call him a dilettante today, there is evidence that he painted, made drawings, sculpture and perhaps engravings.[6] His well-known treatise on architecture, *De re aedificatoria,* is partly based on Vitruvius and other antique texts and partly on his own experience in building. Alberti's architecture need not be discussed here, yet his approach to theory and practice is as typical in the treatise on architecture as it is in any of his other works on the arts. The same approach characterizes his writings in other fields. Although he died a celibate, he felt qualified by his knowledge of literary sources and by his participation in the closely knit *gens* Alberti to write a treatise on the governing of the family. This interest in a wide variety of subjects—from painting to the duties of a pontiff—and his competence in handling them support Burckhardt's characterization of Alberti as the first universal genius.[7]

Although Alberti was certainly not the only man in Florence capable of writing a treatise on the new art of painting, he was

probably better equipped for the task than any other humanist of the time. He had the interest in art which many of his literary friends lacked, and a control of words which no artist of that moment could equal. The literary and philosophical baggage he brought to his task was essential for giving utterance to the principles governing this new art and for convincing both patron and painter that it was an art worth adopting.

Alberti's academic training was not particularly unusual among humanists. At Barzizza's school he was introduced to a body of learning based on the medieval curriculum and on newly discovered antique manuscripts. At the University of Bologna he heightened his critical and synthetic faculties. In *Della pittura* he is well prepared to argue the case for the new art with a crisp Ciceronian logic, illustrated with citations from ancient authors and demonstrated with mathematical proofs. Yet these are only the means employed in the composition of the first modern treatise on the theory of painting; the philosophic bases on which Alberti's thesis rests are no less important.

It would be an exaggeration to dignify Alberti with the title of philosopher; certainly he had no system. Although he probably drifted towards the systemized thought of the Florentine Neo-platonic academy, his relation to this group has been greatly exaggerated by Cristoforo Landino. At the time of the composition of *Della pittura* it is difficult to assign Alberti's thought to any philosophic niche. The influence of the anti-Aristotelian atmosphere at the University of Padua undoubtedly extended to Barzizza's school, where the young Alberti would have acquired a negative view towards Aristotle and the Christianized Aristotle of St. Thomas. The Nominalism of William of Ockham had spread into Italy and was so well established that Nicholas of Cusa, educated in the Ockhamite houses of the Rhine valley, could find a congenial atmosphere at the University of Padua. *Della pittura* certainly reflects the Nominalist approach to knowledge and its acquisition. At the

same time the influence of Cicero extends beyond the rhetoric and organization of the treatise. It seems quite probable that Alberti's thought at the time of the composition of *Della pittura*—as well as of the contemporary *Della famiglia* and *Della tranquillità dell'animo*—could be characterized as a Christianized Ciceronian stoicism. From Cicero he drew a method of analysis and synthesis, with man and his rational processes at its centre. The logic of Ciceronian rhetoric is applied to nature and to art with results that lead Alberti to a buoyant optimism reflected in almost every page of *Della pittura*.

Alberti's thought in this treatise and his other writings of the same period can be briefly summarized. Knowledge comes first from sensory perceptions. These perceptions are compared with each other and related to man in order to derive general conclusions. The conclusions are tested and made applicable by means of mathematics. Alberti is completely self-assured and confident in his method. In his own examination of knowledge, man becomes the point of departure and the centre of the investigation. Because man's knowledge is based on sensory data Alberti is concerned with visual *appearances*. Hence his preoccupation with the extreme limits of things, with the concept of *orlo* or outline, and with the *superficie* or plane defined as the 'certain external part of a body which is known not by its depth but only by its length and breadth and by its quality'.[8] Solid bodies are frequently referred to as having a skin.[9] It is for this reason that Alberti is concerned with the play of light and shade across the surface of an object, for thus the object is known.

Once the sensory observations are made conclusions must be drawn. In Alberti's epistemology this would be done on a comparative basis, for 'comparison contains within itself a power which immediately demonstrates in objects which is more, less or equal'.[10] *De statua* includes a canon of proportions arrived at by this very means. In the same way all Alberti's findings are ultimately related to man, who is the standard by which we know. 'Perhaps Protagoras, by saying that man is

the mode and measure of all things, meant that all the accidents of things are known through comparison to the accidents of man.'[11] This is not a system based on *a priori* absolutes; it is rather a flexible knowledge which depends upon the point of view.

Although the treatise may appear at first glance to rest on rather unstable grounds, Alberti reassures the reader and buttresses his theory with the logic of mathematics. For Alberti and many of his contemporaries Nature, defined as all that outside the individual and of which he is also a part, is homogenous and amorphous. If Nature is homogenous, the whole is knowable from its observable parts. Since man, nature, and mathematics are all parts of the same whole, man has only to use mathematics to understand and to control nature. This is nowhere more clearly evidenced than in Alberti's perspective construction. Here mathematics, although based first on the relative and unknowable man, is used to construct and to control the space which man is to inhabit both as actor and observer.

The essence of Alberti's aesthetics, as well as its relations to his thought, can perhaps be best apprehended through an investigation of three topics basic in the treatise; his approach to visible reality, *la più grassa Minerva*; his use of the mathematical sciences as a means of controlling this reality, *mathematica*; and the means and aim of humanist painting, *istoria*.

La più grassa Minerva

The application of Alberti's epistemology to observable reality and to painting becomes his striking term: *la più grassa Minerva*. As a term it contains two levels of meaning. The first, derived from Cicero, refers to a more popular sort of knowledge or the propagandizing nature of the treatise.[12] Considered out of context the term is practically meaningless, except on the level of Cicero, but the whole phrase, taken with

what we already know of Alberti's thought, elucidates his completely new approach to the art of painting. He says mathematicians examine the form of things separated from matter, but 'since we wish the object to be seen, we will use a more sensate wisdom'.[13] His interest, then, is in form *not* separated from matter and in form as it is visible. This implies matter which, in turn, must be located in space and light to be visible. Ultimately all this will refer back to its basis in man by whom these things are known.

There can be no doubt that Alberti is deeply concerned with vision and visibility throughout *Della pittura*. He states clearly the aim of his investigation: 'No one would deny that the painter has nothing to do with things that are not visible. The painter is concerned solely with representing what can be seen.'[14] He defines the point as a figure which cannot be divided into parts; a figure is anything located on a surface *so the eye can see it*.[15] This definition puts the emphasis on vision while denying the strictly mathematical definition which he retains later in the *Elementi di pittura*. 'They say a point is that which cannot be divided into parts.'[16] The *superficie*, in the same way, is considered primarily as a visible quantity without reference to the matter which lies beneath it. The whole perspective construction is based on monocular vision and is approached by an analysis of vision in which Alberti examines the way bodies seem to change their appearance. Light, though not visible itself, is essential to the whole problem, for 'The philosophers say that nothing can be seen which is not illuminated and coloured.'[17].

A concern with this matter which natural light makes visible pervades the whole of *Della pittura*, rather than the abstractions and geometry that have been called the ruling factors of Alberti's aesthetic. He has a feeling for the materials of the artist—the washes of the underpaint, the pigments of the painting, the gold and jewels of the frame—that could only have come from a man so interested in the problems posed by matter

that he has investigated them personally. The value of the material is separated from the artistic value of the object; 'If figures were made by the hand of Phidias or Praxiteles from lead itself—the lowest of metals—they would be valued more highly than silver.'[18] Yet beyond the matter of his painting the painter must be concerned with the matter of the observable world which exists in space and light. He must find a means of controlling the matter of the macrocosm if he is to represent it in his microcosm.

A large portion of the treatise, especially in Books I and II, is devoted to an investigation of this problem. Early in the first book Alberti briefly shows the painter the method to use for his own personal analysis of observable light phenomena: 'We see green fronds lose their greenness little by little until they finally become pale. Similarly, it is not unusual to see a whitish vapour in the air around the horizon which fades out little by little [as one looks towards the zenith]. We see some roses which are quite purple, others are like the cheeks of young girls, others ivory.'[19] This is the first and empirical approach to matter in space and light, but the painter must represent that which he sees with a different matter and with simulated rather than real light.

In Book II Alberti 'puts the art in the hand of the artist', and shows him how to represent light and shade in the under-painting. When the local colour of the object is applied over the underpaint, it will appear to be seen under light with deeper colours in the shadows gradually fading out as they approach the highlights. This matter, however, exists in space, and for this reason Alberti presents the painter with his mathe-matically derived perspective construction to control and to locate matter in space. By using a reticulated net the painter can locate objects in space and note their reference to each other in planar terms. These observations transferred to the perspective construction will relocate the objects in an apparent space.

Mathematica

Mathematics in Alberti's theory is a means, not an end. In *Della pittura* geometry and the 'maxims of mathematicians' are introduced in order to arrive more quickly and more directly at the basic problems of painting. The emphasis on mathematics in Alberti's theory is more appearance than reality. The fundamentals of the art of painting which are based on geometry occur almost exclusively in the first book where they occupy somewhat less than half of the total space devoted to the rudiments of the art. Actually the first book is only slightly longer than the others. The difficulty of the material and the great number of concepts introduced in this section seem to place the emphasis on mathematics. Alberti clearly states in his dedicatory preface to Brunelleschi that this first book is 'all mathematics, concerning the roots in nature which are the source of this . . . art'.[20] In his own terms, then, mathematics in painting is not an end in itself, but is rather the first of the means by which the painter may arrive at the aims set forth in the remainder of the work.

Alberti's most obvious contribution to the art of painting—on a mathematical level—is his exposition of the one-point perspective system which makes its first appearance in theory in this work. Based on reason and sensory data controlled by mathematics, the construction provides the artist with a means of creating apparent space in his painting. In the monocular vision proposed by Alberti the visual rays extending from the eye to the object seen assume the form of a pyramid. A painting, in Albertian terms, should be an intersection of this pyramid equidistant to the plane seen and at an established distance from the eye. Given such an approach to vision and to the work of art, geometry provides the only certainty for knowledge. By means of plane geometry based on the practice of surveying[21] Alberti analyses the processes of vision and from this analysis draws his synthesis. According to Alberti's concept of vision, the visual rays act as compasses to measure the

height, width and depth of objects seen. Although he does not state it, the eye apparently registers these proportionate quantities automatically without the observer being aware of it. If we wish to understand rationally the data received by sight, we must employ geometry. By means of the similarity of triangles he cuts through the isosceles triangles of sight measuring height and width and the scalene triangle measuring depth to arrive at measurable quantities proportional to the quantities seen but varying with the height and distance of the observer's eye. If the apparent size of an object varies according to the height of the observer's eye above the ground plane and to the distance of the eye from the object, one need only apply the corollary of this theorem to painting in order to relate the space and scale of the observer to the space and scale of the painting. By establishing arbitrarily the position the observer must take to view the painting and by relating all parts of the perspective construction to this position, the artist creates a microcosm. The space of this microcosm seems a continuation of the observer's space and its figures are related to the observer and to the space they inhabit. Certainly, mathematics is at the basis of the perspective construction, but only as a means to achieve ends expressed in Alberti's concept of *istoria*.

At the same time the artist should use mathematics as more than just a control of space in the perspective construction. Towards the end of the first book a canon of human proportions is implied in the construction of the perspective system where one-third the height of a man—one *braccio*—is taken as the module. The discussion and criticism of the Vitruvian canon in the second book stress the necessity of a human unit of measurement—the head—and of a more fully developed canon of human proportion. Although *Della pittura* does not present the artist with such a canon, Alberti's *De statua*, contains a complete system of proportion based on the foot and derived from measurements of a large number of individuals. At the same time, Alberti delves into the allied science of

statics to present the artist with a new means for observing the actions and determining the limits of action of the human figure. This he bases partly on his observations of the human figure and on his earlier work in physics, as a part of the curriculum in philosophy. As a result Alberti is the first to consider the human body as a system of weights and levers, of balances and counter-balances.[22] This contribution, too often attributed to Leonardo da Vinci, has become so much a part of the public domain that it is scarcely necessary to repeat it here. So far as Alberti is concerned, then, mathematics in this treatise can be used by the artist to control the external visual data to be employed in the painting and to control the painting itself. Still, mathematics is only a means to an end. The higher aims of painting are expressed in his concept of *istoria*.

Istoria

The term *istoria*, for which no present-day verbal equivalent exists, is introduced by Alberti towards the middle of the second book; the concept of *istoria* dominates the whole treatise and it is developed at length in the last half of the work. Any reinterpretation of the word must be derived from the treatise itself without dependence on seventeenth- and eighteenth-century *histoires, storie*, or 'histories'. For Alberti the term *istoria* was of greatest consequence—he puts it at the pinnacle of artistic development. Painting was not to impress by its size but rather by its monumentality and dramatic content. 'The greatest work of the painter is not a colossus, but an *istoria*. *Istoria* gives greater renown to the intellect than any colossus.'[23] The themes he urges are primarily derived from ancient literature, yet this is not to be merely an art of illustration. The figures are to be so ordered that their emotion will be projected to the observer. There is to be variety and richness in the painting, yet the painter must exercise self-restraint to avoid excesses. In the new art which Alberti advocates the painter must be capable of employing the perspective construction for the visual, temporal,

and spatial unity which it implies. He must be able to paint with light and shade to obtain modelling, and he must understand the effective use of colour and gesture. To control these many disparate factors the artist of necessity must be a well educated man, but if he handles them well, his art will reward him by rendering 'pleasure, good will and fame'.[24] When all the requirements of Alberti's aesthetic come together in one work of art, the soul of the beholder will be captivated and he will be elevated by his experience. The *istoria* advocated by the treatise, then, is directed towards the expression of a new humanist art which will be capable of incorporating the finds of the literary and theological humanists while at the same time satisfying the demands of the artistic humanist.

On a more concrete level, the content of the *istoria* is fairly well indicated by Alberti in the course of his treatise. It is to be built around antique themes with human gestures to portray and project the emotions of the actors. No doubt Alberti's education and his desire to impress the prospective patron account in large measure for his emphasis on antiquity. On the other hand, Christian themes and iconography had been developed and stabilized by medieval art. There was no necessity for Alberti to reiterate such general knowledge in his brief treatise. Themes from antiquity in painting were new and almost unheard of in the opening years of the fifteenth century. Alberti was introducing his contemporaries to a body of knowledge which was as new and interesting to them as it was to him. The fact that Greco-Roman mythology was not immediately adopted by artists is not because Alberti went unheeded but rather because the awareness of something other than Christian subjects did not seep down through society and create a demand for 'antique illustration' until somewhat later. Of the myriad antique incidents which he certainly must have known and could have chosen Alberti left aside all the lachrymose and erotic. He was interested only in the truly virile emotions. He sought out examples with an inherent stoic

firmness—such as the Death of Meleager, the Immolation of
Iphigenia, and the Calumny of Apelles.

The elemental emotions of such compositions can only be
projected by equally simple gestures. Alberti pauses here to
describe the appearance of a sad or angry person. By his choice
of vocabulary he makes it difficult for the reader to overlook
the psychological effect of observable external manifestations
of the emotions on the beholder. This early analysis of the
expression of the 'passions' is not included solely for the amuse-
ment of the patron or the edification of the painter. Giotto, the
only non-antique painter named in the whole treatise, enters
because in his Navicella in Rome 'eleven disciples [are por-
trayed], all moved by fear at seeing one of their companions
passing over the water. Each one expresses with his face and
gesture a clear indication of a disturbed soul in such a way that
there are different movements and positions in each one.'[25] It is
for this reason that Alberti encourages the painter to make a
study of gestures and the emotions they portray, for only thus—
by externals—can we know the workings of the soul. Like
Cicero's orator, the painter will evoke the desired emotion in
the spectator by a conscious use of gesture. In a passage
reminiscent of Horace,[26] yet which goes beyond Horace,
Alberti states his position. 'The *istoria* will move the soul of the
beholder when each man painted there clearly shows the move-
ment of his own soul. It happens in nature that nothing more
than herself is found capable of things like herself; we weep
with the weeping, laugh with the laughing, and grieve with
the grieving.'[27] This well worn concept is presented for the first
time to the world of European arts and letters: emotions of the
soul may be expressed by the body. Important as this step may
be in the history of art, Alberti intends it only as a reinforce-
ment of his main objective, the definition of affective humanist
painting or *istoria*.

Because he is dealing with simple elemental emotions
Alberti insists that the figures in the painting must exhibit

above all else 'dignità et verecundia'. Even though it may be against absolute veracity, a painter is allowed to conceal artistically the lack of an eye in a king who would otherwise lack dignity.[28] Truth or verisimilitude must go with dignity, for each sort of person has his own sort of dignity which would be destroyed if we were to portray 'Venus or Minerva in the rough wool cloak of a soldier; it would be the same to dress Mars or Jove in the clothes of a woman'.[29] If, however, the painter feels the dignity limits the emotions transmitted by the figures, Alberti suggests the use of a 'commentator'. 'In an *istoria* I like to see someone who admonishes and points out to us what is happening there; or beckons with his hand to see; or menaces with an angry face and with flashing eyes, so that no one should come near; or shows some danger or marvellous thing there; or invites us to weep or to laugh together with them. Thus whatever the painted persons do among themselves or with the beholder, all is pointed towards ornamenting or teaching the *istoria*.'[30] Here again the basic emotions of anger, fear, grief are stressed, but with an essential and important concept added. Not only is the perspective construction to form a spatial link between the painting and the observer, but the commentator is to establish the emotional link. The image of man in the microcosm is in contact with man in the reality of the macrocosm.

However, if the artist does not exercise great care, it is possible for him to fall into monotony or repetition. For this reason Alberti advocates 'variety' and 'copiousness'.[31] He demands richness and variety in the colour chords which the painter is to use,[32] and expects the same variety of human poses and movements.[33] A good painting, he says, will include all ages of man and both sexes as well as animals of all sorts.[34] It might seem that Alberti is here advocating the *horror vacui* of some late medieval painting. He quickly corrects any mis-interpretation we may make of his remarks. Lest any painter should go to extremes in this particular area, Alberti

admonishes: 'I blame those painters who, where they wish to appear copious, leave nothing vacant. It is not composition but dissolute confusion which they disseminate. There the *istoria* does not appear to aim to do something worthy but rather to be in tumult.'[35] As an antidote to this 'dissolute confusion' he suggests that 'solitude in painting' may be pleasing to some. In the Latin text Varro's statement that no more than nine guests should be invited to a banquet is applied to painting, where nine to ten persons are enough to transmit the *istoria*. In the Italian text this passage is omitted, for no fixed number can actually be set for the personages of an *istoria*. The painter, then, is left without the precise rules of the academies, and must choose for himself the proper number of figures needed to make his point without offending by crowding or by barren emptiness.

Alberti has not presented the painter with a rigid set of formulae which he can follow blindly, but has rather put the responsibility for the final outcome of the work of art where it should be—in the hands of the artist. The artist could well ask why he should put himself to so much trouble making decisions and trying to hold himself to some elusive mean. Alberti's answer would probably have been that the final result will be well worth the artist's pains. In words addressed as much to the patron as to the artist he answers, 'The *istoria* which merits both praise and admiration will be so agreeably and pleasantly attractive that it will capture the eye of whatever learned or unlearned person is looking at it and will move his soul.'[36]

This art will not only please the beholder but also touch him. It is to be effective, making a direct link between itself and the beholder. At the same time, it is to affect both educated and uneducated. Unlike many theorists from the sixteenth century to our day Alberti does not believe that art is addressed primarily to an elite; it is to reach all levels of society by the universality of its appeal. Such an art, of necessity, is not to be reserved for the bedroom of a merchant prince or petty tyrant but is to

be made public where all can see it. Like the city republic which he defines as the common property of all citizens,[37] this art is to be the patrimony of all men. It will make the painter's contemporaries 'judge him another god and will give him perpetual fame'; it will 'give the dead life', 'aid religion', and by its example raise the humane level of all men. At the same time it is a profoundly humanist art capable of expressing and of satisfying the intellectual aims and ambitions of both the princely patron and the artist.

Perhaps it was the humanist nature of the art Alberti was advocating which led him in 1435 to write a treatise dedicated to the humanist patron Gianfrancesco Gonzaga of Mantua. He followed this Latin version almost immediately in 1436 with an Italian translation dedicated to artists. Although the Italian version bears no formal dedication as such, Brunelleschi is addressed and named before his colleagues Donatello, Luca della Robbia, Ghiberti and Masaccio. The dual dedication of *Della pittura* is too frequently overlooked. It is, in fact, quite difficult to understand the peculiar bias of the text and its subsequent history without an awareness of this dedication to patron and to painter. The education and interests of patron and painter were understandably different. Alberti, cognizant of this fact, altered his text accordingly. The patron could appreciate the Ciceronian bias and contemporary turn of Alberti's thought. He would be much more interested than the painter in literary and philosophical allusions lacking in the Italian text, but found in subsequent translations based on the Latin version. The artist, on the other hand, might expect to acquire new methods of composing a painting, and would be interested in antique precedents for his art. As spokesman for the 'new art' Alberti had to convince both groups. This he did by following a logic which moves from the simple to the more complex, from the general to the specific. He pauses to sum up what has been treated and interjects 'divertimenti' to pique the

interest of the reader. He admits the difficulty of his material but exhorts one to go on for the rewards will be great. This approach, though far from new, was still effective. The novelty of his theories is minimized by relating them to antique practice and to established contemporary artists. He explains the difficult aspects of his theory in simple terms. The consequences of the first premise are developed logically, and, finally, the art resulting from the theory is made desirable.

In the dedications Alberti's aim in writing *Della pittura* becomes manifest. In addressing the patron he is already indicating the death of the guild system. This 'new art' which he advocates is not to be dependent upon a medieval system for its commissions. Its existence requires a wealthy and educated lay patron. On the other hand he would raise the painter from the level of a craftsman and make him an independent artist. Already the ascendancy of mind over hand is exhibiting itself in painting. Alberti's artist is characterized by his intellect, yet his art is one which must exist in matter. The dichotomy between theory and practice found in the sixteenth century theories of Dolce, Vasari and Pino has no place in *Della pittura*. Alberti's treatise is first of all a work of the fifteenth century both in its aims and in its means. Yet it rises above its own time by expressing concepts that open the modern era and give direction to the future development of painting.

The appearance of *Della pittura* must have caused a great stir in artistic circles in Florence in 1436. Based as it is on the work of the avant-garde artists of the moment and on Alberti's growing reputation as a humanist thinker, the treatise must have carried considerable weight. Although no documents are known which prove the acceptance of Alberti's theory by painters of the fifteenth century, investigation of the internal data of Florentine painting of this period indicates a clear relation to the body of the treatise.

Since Masaccio was already dead when *Della pittura* was

being written, and since a part of the art advocated in the treatise is based on his work, we need only be concerned with the effect of the document on painters after 1436. The influence of the theory in Florence and its dissemination throughout Italy are much too complex a subject to be more than outlined here.

In Florence the aims and means of *Della pittura* were adopted almost immediately. Two works of art, both of 1439, clearly document the impact of the treatise on what could be called 'the moment of acceptance'. Although nothing remains of Domenico Veneziano's frescoes for Sant'Egidio but an ortho-gonal and a part of a leg, it is clear from Vasari's description and the extant fragment that Alberti's influence was parti-cularly strong here. Of greater importance is Fra Angelico's so-called '1439 altarpiece' and its predella (commissioned by Cosimo de' Medici for the high altar of San Marco; now in Museo S. Marco, Florence; predella in Munich, Paris, Dublin, and Florence). One has only to compare this altarpiece with the Cortona polyptych ('Virgin and Child enthroned between Saints John the Evangelist, John the Baptist, Mark and Mary Magdalen' at S. Domenico, Cortona) to see the effect of the treatise on the Dominican monk. Far from being a *retardataire* and mystic artist, Fra Angelico adopts Alberti's concepts of space and of *istoria* in his S. Marco altarpiece. One-point per-spective is used; the figures are interrelated by pose and gesture, while a 'commentator' establishes the emotive link with the observer. Rather than looking back, Fra Angelico is here pointing the way to the future and the *Sacra conversazione*.

Although they belong to the same historical moment, Paolo Uccello and Fra Filippo Lippi are omitted from this dis-cussion, because the impact of *Della pittura* on their art is a more complex subject. Close analysis of Uccello's extant work indicates that he did not employ an accurate one-point perspective until the 'Profanation of the Host' predella at Urbino. Fra Filippo's sporadic acceptance of the aesthetic, as

in the lower register at Prato, followed by its rejection, as in his Madonnas, merits more detailed treatment.

The widest acceptance of the art advocated by Alberti seems to appear in the decade following the publication of *Della pittura*. During this period his theories made their way in one form or another into practically all the painting produced in Florence.

Towards mid-century a 'moment of modification' begins to appear. At this time a group of younger painters headed by Piero della Francesca altered 'Albertian painting' to obtain a greater monumentality and freedom in locating their figures in space. Castagno and Domenico Veneziano move away from *Della pittura* towards more personal solutions. However, this group never breaks completely with Alberti, for Piero's frescoes at Arezzo are probably the finest illustration of Alberti's colour chords. The period of 1460–80 could be characterized as a 'moment of rejection'. Both Pollaiuolo and Botticelli move away from Masaccio and the style of painting built on his art towards a greater interest in surface pattern and mobility of line rather than space and monumentality. By 1480, however, there arose a new desire to seek a means of ordering the composition of a painting. Leonardo's 'Adoration of the Magi' of 1481 with its attendant drawings most clearly illustrates this almost academic return to the concepts of the art of an earlier period. Ultimately this revival leads to a synthesis—expressed in Raphael's 'School of Athens'—of the spatial control from the 'moment of acceptance' and the freedom of figure disposition from the 'moment of rejection'.

Della pittura is by no means the complete answer to the often complex and confusing questions posed by Quattrocento Florentine painting. However, the old categories of 'romantic' and 'realist' have not been of great value in an attempt to understand this epochal period of art. I would stress the notion that the theory contained in *Della pittura* is best studied as a 'control' —as in a scientific experiment—for a clearer analysis of a most

complex period of development. The theory has its roots in Quattrocento practice. As a theory it gives expression and codification to the dimly felt and unexpressed concepts of this practice. The aims suggested and the problems posed by the treatise give a new direction to painting. As a control, it is capable of embracing both the 'romantic' Fra Angelico and the 'realist' Piero della Francesca. Taken as a document of the fifteenth century, apart from the academic theory and practices that grew out of it, *Della pittura* is capable of bringing us closer to the vitality of Quattrocento painting as it appeared to the patrons and painters of the time.

SOURCES

THIS translation is based solely on manuscript sources. Of these the Italian manuscript, MI, is the most important. All the other known Italian and Latin manuscripts have been collated with MI in order to obtain clearer readings, variants and emendations for this text. The known extant manuscripts can be described briefly in order of importance.[38]

Italian Manuscripts.

MI Florence, Biblioteca Nazionale, Magl. II, IV, 38. Fifteenth century, paper (21.5 × 29.5 cm.). Folios 120r–136v.

P Paris, Bibliothèque Nationale. Fonds italien 1692. Fifteenth century, paper (14 × 20 cm.). Folios 1r–31r. Corrupt.

Latin Manuscripts.

O Vatican, Codex Ottoboniani Latini 1424. Fifteenth century, paper (27 × 39 cm.). Folios 1r–25v.

OF Vatican, Cod. Ottobon. Lat. 2274. Fifteenth century, paper (14.5 × 20.5 cm.). Folios 1r–42v. Fragmentary.

RL Vatican, Codex Reginenses Latini 1549. Fifteenth century, parchment (13.5 × 20 cm.). Folios 1r–32v.

NC University of North Carolina. Uncatalogued. Fifteenth century, paper (20 × 30 cm.). Folios 1r–23v.

R Florence, Biblioteca Riccardiana, 767. Fifteenth cen-
 tury, paper (21 × 28 cm.). Folios 65r–103v.

ML Florence, Biblioteca Nazionale. Magl. II, VIII, 58.
 Fifteenth century, paper (21 × 28 cm.). Folios 1r–26v.

A comparison of attributed holograph material with the
extant manuscripts proves that none of the known versions of
the text is in Alberti's own hand. For this reason we must
postulate lost holograph Latin and Italian versions, XL and
XI respectively, as sources of the present texts. Their genealogy
can be illustrated graphically with the addition of a lost Latin
manuscript (YL) to explain the variants of R and ML and a
lost Italian version YI as a source for P.

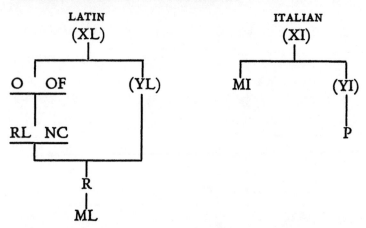

Until the nineteenth century translators and editors of *Della
pittura* made no mention of their manuscript source. In 1847
Bonucci published for the first time what he thought was the
holograph Italian version, MI. Janitschek based his Italian-
German version on O, R, and MI, although he also knew OF
and RL. Papini uses only MI. Mallé has used only MI, O,
and the first printed edition of the text. Former editors have
consulted manuscripts OF and RL to a limited extent; ML,
NC, and P have never before been used. The printed editions
of *Della pittura* are as follows:[39]

1.	1540	Basle.	Thomas Venatorium. Latin text.
2.	1547	Venice.	Lodovico Domenichi Italian translation from Latin.
3.	1565	Monte Regale.	Bartoli edition of 2.
4.	1568	Florence.	Re-edition of 2.
5.	1568	Venice.	Bartoli Italian translation. *Opere morali di Leon Battista Alberti.*
6.	1649	Amsterdam.	(Printed in Leyden). Elzevir. Latin text.
7.	1651	Paris.	DuFresne translation from Bartoli (5).
8.	1726	London.	Leoni translation based on Bartoli.
9.	1733	Naples.	Rispoli re-edition of DuFresne.
10.	1739	London.	Re-edition of 8.
11.	1751	London.	Leoni translation based on Elzevir (6).
12.	1755	London.	Leoni translation based on DuFresne (7).
13.	1782	Bologna.	Re-edition of Bartoli.
14.	1782	Bologna.	Re-edition of DuFresne.
15.	1784	Madrid.	D. Diego Antonio Rejon de Silva translation.
16.	1786	Bologna.	Re-edition of DuFresne.
17.	1803	Milan.	Re-edition of 13.
18.	1804	Perugia.	Re-edition of 13.
19.	1804	Milan.	Re-edition of 13.
20.	1827	Madrid.	Re-edition of 15.
21.	1843–44–45–47–49.		Florence. Bonucci, *Opere volgare* in five volumes.
22.	1868	Paris.	Popelin translation.
23.	1877	Vienna.	Janitschek translation with Italian text. Part of *Quellenschriften für Kunstgeschichte* series.
24.	1913	Lanciano.	Papini re-edition and correction of 23.
25.	1950	Florence.	Mallé edition.

Ideally the translation which follows should be read in conjunction with Alberti's Italian or Latin. Since it was not considered practical at the present time to bring out a definitive edition of the text along with the translation, the serious student is recommended to Luigi Mallé's edition (Sansoni, Florence, 1950) as by far the best published Italian version of the text. The major Latin variants are inserted in italics in this translation at the point where they would normally occur in the text.

NOTES TO INTRODUCTION

1. Paolo Pino (*Dialogo di pittura*. Venice, 1548. folio 2v) knew only the Latin version of *Della pittura*. The need for an Italian version is attested by two sixteenth-century translations. See 2 and 5, p. 35.

2. See below, p. 39.

3. C. Ceschi, 'La Madre di Leon Battista Alberti', *Bolletino d'arte*, 1948, 191–2.

4. L. B. Alberti, *De re aedificatoria,* II, ix and xi.

5. For fuller discussion of Alberti's life see Girolamo Mancini, *Vita di Leon Battista Alberti* (2nd ed., Florence, 1911).

6. See below, pp. 51, 55, 67, 70–1, 77–8.

Also L. B. Alberti, 'Della traquillità dell'animo', *Opere volgare di L. B. Alberti*, Bonucci ed. (Florence, 1843–9), I, 26.

'Vita anonima', *Rerum italicarum scriptores,* Lodovico Muratori, ed. (Milan, 1751), XXV, cols. 295A and 299C.

Giorgio Vasari, *Vite*, Milanesi ed. (Florence, 1878), II, 546–7.

7. Jacob Burckhardt, *The Civilization of the Renaissance in Italy* (London and New York, 1951), pp. 85–7.

8. See below, p. 44.

9. Below, p. 45.

10. Below, p. 55.

11. Below, p. 55.

12. See text note 7, Book One.

13. Below, p. 43.

14. Below, p. 43.

15. Below, p. 43.
16. L. B. Alberti, 'Elementi di Pittura', *Opera inedita et pauca separatim impressa,* G. Mancini, ed. (Florence, 1890), p. 48.
17. Below, p. 49.
18. Below, p. 64.
19. Below, p. 50.
20. Below, p. 40.
21. See below note 48, Book One.
22. Below, pp. 79–80.
23. Below, p. 72. See also text note 36, Book Two.
24. Below, p. 89.
25. Below, p. 78.
26. Quintus Flaccus Horace. *De arte poetica,* lines 101–3.
27. Below, p. 77.
28. Below, p. 76.
29. Below, p. 74.
30. Below, p. 78.
31. Below, p. 75 ff.
32. Below, pp. 82, 84–5.
33. Below, pp. 75–6.
34. Below, p. 75.
35. Below, pp. 75–6.
36. Below, p. 75.
37. L. B. Alberti, *De re aedificatoria,* IV, ii.
38. Professors Paul O. Kristeller and Cecil Grayson have brought to my attention eight additional manuscripts of *Della pittura* that I have not been able to consult.
39. After P.-H. Michel, *La Pensée de L. B. Alberti* (Paris 1930), with additions.

Prologue[1]

I used to marvel and at the same time to grieve that so many excellent and superior arts and sciences from our most vigorous antique past could now seem lacking and almost wholly lost. We know from [remaining] works and through references to them that they were once widespread. Painters, sculptors, architects, musicians, geometricians, rhetoricians, seers and similar noble and amazing intellects are very rarely found today and there are few to praise them. Thus I believed, as many said, that Nature, the mistress of things, had grown old and tired. She no longer produced either geniuses or giants which in her more youthful and more glorious days she had produced so marvellously and abundantly.

Since then, I have been brought back here [to Florence]— from the long exile[2] in which we Alberti have grown old— into this our city, adorned above all others. I have come to understand that in many men, but especially in you, Filippo, and in our close friend Donato the sculptor and in others like Nencio, Luca and Masaccio,[3] there is a genius for [accomplishing] every praiseworthy thing. For this they should not be slighted in favour of anyone famous in antiquity in these arts. Therefore, I believe the power of acquiring wide fame in any art or science[4] lies in our industry and diligence more than in the times or in the gifts of nature. It must be

admitted that it was less difficult for the Ancients—because they had models to imitate and from which they could learn—to come to a knowledge of those supreme arts which today are most difficult for us. Our fame ought to be much greater, then, if we discover unheard-of and never-before-seen arts and sciences without teachers or without any model whatsoever. Who could ever be hard or envious enough to fail to praise Pippo the architect on seeing here such a large structure, rising above the skies, ample to cover with its shadow all the Tuscan people, and constructed without the aid of centering or great quantity of wood?[5] Since this work seems impossible of execution in our time, if I judge rightly, it was probably unknown and unthought of among the Ancients. But there will be other places, Filippo, to tell of your fame, of the virtues of our Donato, and of the others who are most pleasing to me by their deeds.

As you work from day to day, you persevere in discovering things through which your extraordinary genius acquires perpetual fame. If you find the leisure, it would please me if you should look again at this my little work On Painting[6] which I set into Tuscan for your renown. You will see three books; the first, all mathematics, concerning the roots in nature which are the source of this delightful and most noble art. The second book puts the art in the hand of the artist, distinguishing its parts and demonstrating all. The third introduces the artist to the means and the end, the ability and the desire of acquiring perfect skill and knowledge in painting. May it please you, then, to read me with diligence. If anything here seems to you to need emending, correct me. There was never a writer so learned to whom erudite friends were not useful. I in particular desire to be corrected by you in order not to be pecked at by detractors.

Book One

Book One

TO make clear my exposition in writing this brief commentary on painting, I will take first from the mathematicians those things with which my subject is concerned. When they are understood, I will enlarge on the art of painting from its first principles in nature in so far as I am able.

In all this discussion, I beg you to consider me not as a mathematician but as a painter writing of these things. Mathematicians measure with their minds alone the forms of things separated from all matter. Since we wish the object to be seen, we will use a more sensate wisdom.[7] We will consider our aim accomplished if the reader can understand in any way this admittedly difficult subject—and, so far as I know, a subject never before treated. Therefore, I beg that my words be interpreted solely as those of a painter.

I say, first of all, we ought to know that a point is a figure which cannot be divided into parts. I call a figure here anything located on a plane so the eye can see it. No one would deny that the painter has nothing to do with things that are not visible.[8] The painter is concerned solely with representing what can be seen. These points, if they are joined one to the other in a row, will form a line. With us a line is a figure whose length can be divided but whose width is so fine that it cannot be split. Some lines are called straight, others curved. A straight line is drawn

directly from one point to another as an extended point. The curved line is not straight from one point to another but rather looks like a drawn bow.[9] More lines, like threads woven together in a cloth, make a plane.[10] The plane is that certain external part of a body which is known not by its depth but only by its length and breadth and by its quality. Some qualities remain permanently on the plane in such a manner that they cannot be changed without altering the plane itself. Other qualities are such that, due to visual effects, they seem to change to the observer even though the plane remains the same.

Permanent qualities are of two kinds. One is known by the outermost boundary[11] which encloses the plane and may be terminated by one or more lines. Some are circular, others are a curved and a straight line or several straight lines together. The circular is that which encloses a circle. A circle is that form of a plane which an entire line encircles like a garland. If a point is established in the middle, all lines from this point to the garland will be equal. This point in the middle is called the centre. A straight line which covers the point and cuts the circle into two parts is called the diameter among mathematicians, but I prefer to call it the centric line. Let us agree with the mathematicians who say that no line cuts equal angles on the circumference unless it is a straight line which covers the centre.

But let us return to the plane. It is clear that as the movement[12] of the outline is changed the plane changes both name and appearance so that it is now called a triangle, now a quadrangle and now a polygon. The outline is said to be changed if the lines are more or less lengthened or shortened, or better, if the angles are made more acute or more obtuse. It would be well to speak of angles here.

I call angles the certain extremity of a plane made of two lines which cut each other. There are three kinds of angles: right, obtuse, acute. A right angle is one of four made by two straight lines where one cuts the other in such a way that each

of the angles is equal to the others. From this it is said that all right angles are equal. The obtuse angle is that which is greater than the right, and that which is lesser is called acute.

Again let us return to the plane. Let us agree that so long as the lines and the angles of the outline do not change, the plane will remain the same. We have then demonstrated a quality which is never separated from the plane.

We have now to treat of other qualities which rest like a skin[13] over all the surface of the plane. These are divided into three sorts. Some planes are flat, others are hollowed out, and others are swollen outward and are spherical. To these a fourth may be added which is composed of any two of the above. The flat plane is that which a straight ruler will touch in every part if drawn over it. The surface of the water is very similar to this. The spherical plane is similar to the exterior of a sphere. We say the sphere is a round body, continuous in every part; any part on the extremity of that body is equidistant from its centre. The hollowed plane is within and under the outermost extremities of the spherical plane as in the interior of an egg shell. The compound plane is in one part flat and in another hollowed or spherical like those on the interior of reeds or on the exterior of columns.[14]

The outline and the surface,[15] then, give their names to the plane but there are two qualities by which the plane is not altered, [although it appears to be]. These take their variations from the changing of place and of light. Let us speak first of place, then of light, and investigate in what manner the qualities of the plane appear to change.

This has to do with the power of sight, for as soon as the observer changes his position these planes appear larger, of a different outline or of a different colour. All of [these qualities] are measured with sight. Let us investigate the reasons for this, beginning with the maxims of philosophers who affirm that the plane is measured by rays that serve the sight—called by them visual rays—which carry the form of the thing seen to the

sense.[16] *For these same rays extended between the eye and the plane seen come together very quickly by their own force and by a certain marvellous subtlety, penetrating the air and thin and clear objects they strike against something dense and opaque, where they strike with a point and adhere to the mark they make. Among the ancients there was no little dispute whether these rays came from the eye or the plane. This dispute is very difficult and is quite useless for us. It will not be considered.* We can imagine those rays to be like the finest hairs of the head, or like a bundle, tightly bound within the eye where the sense of sight has its seat. The rays, gathered together within the eye, are like a stalk; the eye is like a bud which extends its shoots rapidly and in a straight line to the plane opposite.[17]

Among these rays there are differences in strength and function which must be recognized. Some of these rays strike the outline of the plane and measure its quantity. Since they touch the ultimate and extreme parts of the plane, we can call them the extreme or, if you prefer, extrinsic. Other rays which depart from the surface of the plane for the eye fill the pyramid—of which we shall speak more later—with the colours and brilliant lights with which the plane gleams; these are called median rays. Among these visual rays there is one which is called the centric. Where this one touches the plane, it makes equal and right angles all around it. It is called centric for the same reason as the aforementioned centric line.[18]

We have found three different sorts of rays: extreme, median and centric. Now let us investigate how each ray affects the sight. First we shall speak of the extreme, then of the median, finally of the centric.

With the extreme rays quantity is measured. All space on the plane that is between any two points on the outline is called a quantity. The eye measures these quantities with the visual rays as with a pair of compasses. In every plane there are as many quantities as there are spaces between point and point. Height from top to bottom, width from left to right, breadth from near to far and whatever other dimension or measure which is made

by sight makes use of the extreme rays. For this reason it is said that vision makes a triangle. The base of [this triangle] is the quantity seen and the sides are those rays which are extended from the quantity to the eye. It is, therefore, very certain that no quantity can be seen without the triangle. The angles in this visual triangle are first, the two points of the quantity, the third, that which is opposite the base and located within the eye.[19] *Nor is this the place to discuss whether vision, as it is called, resides at the juncture of the inner nerve or whether images are formed on the surface of the eye as on a living mirror. The function of the eyes in vision need not be considered in this place. It will be enough in this commentary to demonstrate briefly things that are essential.*

Here is a rule: as the angle within the eye becomes more acute, so the quantity seen appears smaller. From this it is clear why a very distant quantity seems to be no larger than a point. Even though this is so, it is possible to find some quantities and planes of which the less is seen when they are closer and more when they are farther away. The proof of this is found in spherical bodies. Therefore, the quantities, through distance, appear either larger or smaller. Anyone who understands what has already been said will understand, I believe, that as the interval is changed the extrinsic rays become median and in the same manner the median extrinsic. He will understand also that where the median rays are made extrinsic that quantity will appear smaller. And the contrary: when the extreme rays are directed within the outline, as the outline is more distant, so much the quantity seen will seem greater. Here I usually give my friends a similar rule: as more rays are used in seeing, so the thing seen appears greater; and the fewer the rays, the smaller.

The extrinsic rays, thus encircling the plane—one touching the other—enclose all the plane like the willow wands of a basket-cage, and make, as is said, this visual pyramid. It is time for me to describe what this pyramid is and how it is constructed by these rays. I will describe it in my own way.[20] The pyramid is a figure of a body from whose base straight lines are

drawn upward, terminating in a single point. The base of this pyramid is a plane which is seen. The sides of the pyramid are those rays which I have called extrinsic. The cuspid, that is the point of the pyramid, is located within the eye where the angle of the quantity is. Up to this point we have talked of the extrinsic rays of which this pyramid is constructed. It seems to me that we have demonstrated the varied effects of greater and lesser distances from the eye to the thing seen.

Median rays, that multitude in the pyramid [which lie] within the extrinsic rays, remain to be treated. These behave, in a manner of speaking, like the chameleon, an animal which takes to itself the colours of things near it. Since these rays carry both the colours and lights on the plane from where they touch it up to the eye, they should be found lighted and coloured in a definite way wherever they are broken. The proof of this is that through a great distance they become weakened. I think the reason may be that weighted down with light and colour they pass through the air, which, being humid with a certain heaviness, tires the laden rays. From this we can draw a rule: as the distance becomes greater, so the plane seen appears more hazy. The central ray now remains to be treated. The central ray is that single one which alone strikes the quantity directly, and about which every angle is equal. This ray, the most active and the strongest of all the rays, acts so that no quantity ever appears greater than when struck by it. We could say many things about this ray, but this will be enough—tightly encircled by the other rays, it is the last to abandon the thing seen, from which it merits the name, prince of rays.

I think I have clearly demonstrated that as the distance and the position of the central ray are changed the plane appears altered. Therefore, the distance and the position of the central ray are of greatest importance to the certainty of sight.

There is yet a third thing which makes the plane appear to change. This comes from the reception of light. You see that spherical and concave planes have one part dark and another

bright when receiving light. Even though the distance and position of the centric line are the same, when the light is moved those parts which were first bright now become dark, and those bright which were dark. Where there are more lights, according to their number and strength, you see more spots of light and dark.

This reminds me to speak of both colour and light. It seems obvious to me that colours take their variations from light, because all colours put in the shade appear different from what they are in the light. Shade makes colour dark; light, where it strikes, makes colour bright. The philosophers say that nothing can be seen which is not illuminated and coloured. Therefore, they assert that there is a close relationship between light and colour in making each other visible. The importance of this is easily demonstrated for[21] when light is lacking colour is lacking and when light returns the colours return. Therefore, it seems to me that I should speak first of colours; then I shall investigate how they vary under light.[22] *Let us omit the debate of philosophers where the original source of colours is investigated, for what help is it for a painter to know in what mixture of rare and dense, warm and dry, cold and moist colour exists? However, I do not despise those philosophers who thus dispute about colours and establish the kinds of colours at seven. White and black [are] the two extremes of colour. Another [is established] between them. Then between each extreme and the middle they place a pair of colours as though undecided about the boundary, because one philosopher allegedly knows more about the ex-treme than the other. It is enough for the painter to know what the colours are and how to use them in painting. I do not wish to be contra-dicted by the experts, who, while they follow the philosophers, assert that there are only two colours in nature, white and black, and there are others created from mixtures of these two. As a painter I think thus about colours. From a mixture of colours almost infinite others are created.* I speak here as a painter.

Through the mixing of colours infinite other colours are born, but there are only four true colours—as there are four

elements—from which more and more other kinds of colours may be thus created. Red is the colour of fire, blue of the air, green of the water, and of the earth grey and ash.[23] Other colours, such as jasper and porphyry, are mixtures of these. Therefore, there are four genera of colours, and these make their species[24] according to the addition of dark or light, black or white. They are thus almost innumerable. We see green fronds lose their greenness little by little until they finally become pale. Similarly, it is not unusual to see a whitish vapour in the air around the horizon which fades out little by little [as one looks towards the zenith]. We see some roses which are quite purple, others are like the cheeks of young girls,[25] others ivory. In the same way the earth[en colour], according to white and black, makes its own species of colours.

Therefore, the mixing of white does not change the genus of colours but forms the species. Black contains a similar force in its mixing to make almost infinite species of colour. In shadows colours are altered. As the shadow deepens the colours empty out, and as the light increases the colours become more open and clear. For this reason the painter ought to be persuaded that white and black are not true colours but are alterations of other colours. The painter will find nothing with which to represent the brightest lustre of light but white and in the same manner only black to indicate the shadows. I should like to add that one will never find black and white unless they are [mixed] with one of these four colours.

Here follow my remarks on light. Some lights are from the stars, as from the sun, from the moon and that other beautiful star Venus.[26] Other lights are from fires, but among these there are many differences. The light from the stars makes the shadow equal to the body, but fire makes it greater.

Shadow in which the rays of light are interrupted remains to be treated. The interrupted rays either return from whence they came or are directed elsewhere. They are directed elsewhere, when, touching the surface of the water, they strike the rafters

of a house. More can be said about this reflection which has to do with these miracles of painting which many of my friends have seen done by me recently in Rome.[27] It is enough [to say] here that these reflected rays carry with themselves the colour they find on the plane. You may have noticed that anyone who walks through a meadow in the sun appears greenish in the face.

Up to this point we have talked of planes and rays; we have said how a pyramid is made in vision; we have proved the importance of distance and position of the centric ray together with the reception of light. Now, since in a single glance not only one plane but several are seen, we will investigate in what way many conjoined [planes] are seen. Each plane contains in itself its pyramid of colours and lights. Since bodies are covered with planes, all the planes of a body seen at one glance will make a pyramid packed[28] with as many smaller pyramids as there are planes.

Some will say here of what use to the painter is such an investigation? I think every painter, if he wishes to be a great master, ought to understand clearly the similarities and the distinctions[29] of the planes, a thing known to very few. Should you ask some what they are doing when they cover a plane with colours, they will answer everything but what you ask. Therefore, I beg studious painters not to be embarrassed by what I say here. It is never wrong to learn something useful to know from anyone. They should know that they circumscribe the plane with their lines. When they fill the circumscribed places with colours, they should only seek to present the forms of things seen on this plane as if it were of transparent glass. Thus the visual pyramid could pass through it, placed at a definite distance with definite lights and a definite position of centre in space and in a definite place in respect to the observer. Each painter, endowed with his natural instinct,[30] demonstrates this when, in painting this plane, he places himself at a distance as if searching the point and angle of the pyramid from which point he understands the thing painted is best seen.

Where this is a single plane, either a wall or a panel on which the painter attempts to depict several planes comprised in the visual pyramid, it would be useful to cut through this pyramid in some definite place, so the painter would be able to express in painting similar outlines and colours with his lines. He who looks at a picture, done as I have described [above], will see a certain cross-section of a visual pyramid, artificially represented with lines and colours on a certain plane according to a given distance, centre and lights. Now, since we have said that the picture is a cross-section of the pyramid we ought to investigate what importance this cross-section has for us. Since we have these knowns, we now have new principles with which to reason about the plane from which we have said the pyramid issues.

I say that some planes are thrown back on the earth and lie like pavements or the floors of buildings; others are equidistant to these. Some stand propped up on their sides like walls; other planes are collinear to these walls. Planes are equidistant when the distance between one and the other is equal in all its parts. Collinear planes are those which a straight line will touch equally in every part as in the faces of quadrangular pilasters placed in a row in a portico.[31] These things are to be added to our treatment of the plane, intrinsic and extrinsic and centric rays and the pyramid. Let us add the axiom of the mathematicians where it is proved that if a straight line cuts two sides of a triangle, and if this line which forms a triangle is parallel to a side of the first and greater triangle, certainly this lesser triangle will be proportional to the greater. So much say the mathematicians.

I shall speak in a broader manner to make my statements clearer. It is useful to know what the term proportional means. Proportional triangles are said to be those whose sides and angles contain a ratio to each other. If one side of a triangle is two times as long as its base and the other side three, every single triangle—whether larger or smaller, but having this same

relationship to its base—will be proportional to this first, because the ratio which is in every part of the smaller triangle is also the same in the larger. Therefore, all triangles thus composed will be proportional to each other.[32] To understand this better we will use a simile. A small man is proportional to a larger one, because the same proportions between the palm and the foot, the foot and the other parts of the body were in Evander as in Hercules whom Aulus Gellius considered to be the largest of men.[33] There was no difference in the proportions of the bodies of Hercules and Antaeus the giant, for both contained the same ratio and arrangement of hand to forearm, forearm to head and thus through all the members. In the same way a measure is found by which a smaller triangle is equal to a greater—except in size. Here I must insist with the mathematicians, in so far as it pertains to us, that the intercision of any triangle, if it is parallel to the base, makes a new triangle proportionate to the larger one. Things which are proportional to each other correspond in every part, but where they are different and the parts do not correspond they are certainly not proportional.

As I have said, the parts of the visual triangle are rays. These will be equal, as to number, in proportionate quantities and unequal in non-proportional, because one of the non-proportional quantities will occupy more or less rays. You see, then, how a lesser triangle can be proportional to a greater, and you have already learned that the visual pyramid is composed of triangles.

Now let us translate our thinking to the pyramid. We should be persuaded that no quantities equidistant to the cross-section can make any alteration in the picture, because they are similar to their proportionates in every equidistant intercision. From this it follows that when the quantity with which the outline is constructed is not changed, there will be no alteration of the same outline in the picture. It is now manifest that every cross-section of the visual pyramid which is equidistant to the plane

of the thing seen will be proportional to that observed plane.[34]

We have talked about the plane proportional to the cross-section, that is, equidistant, to the painted plane; but since many planes are found to be non-equidistant, we ought to make a diligent investigation of these in order that our reasoning about the cross-section may be clear. It would be long, difficult and obscure in these cross-sections of triangles and pyramids to follow everything with the rule of mathematics, so let us rather continue speaking as painters. I shall treat most briefly of the non-equidistant quantities. When they are known, we will easily understand the non-equidistant planes.

Some non-equidistant quantities[35] are collinear to the visual rays, others are equidistant to the visual rays. Quantities collinear to the visual rays have no place in the cross-section, because they do not make a triangle nor do they occupy a number of rays. In quantities equidistant to the visual rays, as the angle which is greatest in the triangle is more obtuse at the base, so that quantity will occupy fewer rays and for this reason less space in the cross-section. We have said concerning this that the plane is covered with quantities, but it happens frequently that there are several quantities in a plane equidistant to the cross-section. Quantities so composed will certainly make no alteration in the picture. In such quantities which are truly non-equidistant the greater the angle at the base the greater alteration they will make.

It would be well to add to the above statements the opinion of philosophers who affirm that if the sky, the stars, the sea, mountains and all bodies should become—should God so will[36]—reduced by half, nothing would appear to be diminished in any part to us. All knowledge of large, small; long, short; high, low; broad, narrow; clear, dark; light and shadow and every similar attribute is obtained by comparison. Because they can be, but are not necessarily, conjoined with objects, philosophers are accustomed to call them accidents. Virgil says

that Aeneas stood head and shoulders above other men, but placed next to Polyphemus he seemed a dwarf. Nisus and Euryalus were most handsome, but compared to Ganymede who was abducted by the Gods, they would probably have seemed most ugly.[37] Among the Spanish many young girls appear fair who among the Germans would seem dusky and dark.[38] Ivory and silver are white; placed next to the swan or the snow they would seem pallid. For this reason things appear most splendid in painting where there is good proportion of white and black similar to that which is in the objects—from the lighted to the shadowed.

Thus all things are known by comparison, for comparison contains within itself a power which immediately demonstrates in objects which is more, less or equal. From which it is said that a thing is large when it is greater than something small and largest when it is greater than something large; bright when it is brighter than shadow, brilliant when it is brighter than something bright. This is best done with well-known things.

Since man is the thing best known to man, perhaps Protagoras, by saying that man is the mode and measure of all things, meant that all the accidents of things are known through comparison to the accidents of man.[39] In what I say here, I am trying to make it understood that no matter how well small bodies are painted in the picture they will appear large and small by comparison with whatever man is painted there. It seems to me that the antique painter, Timantes, understood this force of comparison, for in painting a small panel of a gigantic sleeping Cyclops he put there several satyrs who were measuring the giant's thumb; by comparison with them the sleeper seemed immense.[40]

Up to this point we have talked about what pertains to the power of sight and to the cross-section. Since it is not enough for the painter to know what the cross-section is, but since he should also know how to make it, we will treat of that. Here alone, leaving aside other things, I will tell what I do when I paint.

First of all about where I draw. I inscribe a quadrangle of right angles, as large as I wish, which is considered to be an open window through which I see what I want to paint.[41] Here I determine as it pleases me the size of the men in my picture. I divide the length of this man in three parts. These parts to me are proportional to that measurement called a *braccio*, for, in measuring the average man it is seen that he is about three *braccia*.[42] With these *braccia* I divide the base line of the rectangle into as many parts as it will receive. To me this base line of the quadrangle is proportional to the nearest transverse and equidistant quantity seen on the pavement.[43] Then, within this quadrangle, where it seems best to me, I make a point which occupies that place where the central ray strikes. For this it is called the centric point. This point is properly placed when it is no higher from the base line of the quadrangle than the height of the man that I have to paint there. Thus both the beholder and the painted things he sees will appear to be on the same plane.[44]

The centric point being located as I said, I draw straight lines from it to each division placed on the base line of the quadrangle. These drawn lines, [extended] as if to infinity, demonstrate to me how each transverse quantity is altered visually.[45]

Here some would draw a transverse line parallel to the base line of the quadrangle. The distance which is now between the two lines they would divide into three parts and, moving away a distance equal to two of them, add on another line. They would add to this one another and yet another, always measuring in the same way so that the space divided in thirds which was between the first and second always advances the space a determined amount. Thus continuing, the spaces would always be—as the mathematicians say—*superbipartienti*[46] to the following spaces. I can say those who would do thus, even though they follow the good way of painting in other things, would err. Because if the first line is placed by chance,

even though the others follow logically one can never know certainly where the point of the visual pyramid lies. From this no small errors arise in painting. Add to this how much the reason [of such painters] is faulty when the centric point is placed higher or lower than the height of the depicted men.

Know that a painted thing can never appear truthful where there is not a definite distance for seeing it. I will give the reason for this if ever I write of my demonstrations which were called miracles by my friends when they saw and marvelled at them. Much of it is relevant to what I have said up to here.

Let us return to our subject. I find this way to be best. In all things proceed as I have said, placing the centric point, drawing the lines from it to the divisions of the base line of the quadrangle. In transverse quantities where one recedes behind the other I proceed in this fashion. I take a small space in which I draw a straight line and this I divide into parts similar to those in which I divided the base line of the quadrangle. Then, placing a point at a height equal to the height of the centric point from the base line, I draw lines from this point to each division scribed on the first line. Then I establish, as I wish, the distance from the eye to the picture. Here I draw, as the mathematicians say, a perpendicular cutting whatever lines it finds. A perpendicular line is a straight line which, cutting another straight line, makes equal right angles all about it. The intersection of this perpendicular line with the others gives me the succession of the transverse quantities. In this fashion I find described all the parallels, that is, the square[d] *braccia* of the pavement in the painting. If one straight line contains the diagonal[47] of several quadrangles described in the picture, it is an indication to me whether they are drawn correctly or not. Mathematicians call the diagonal of a quadrangle a straight line [drawn] from one angle to another. [This line] divides the quadrangle into two parts in such a manner that only two triangles can be made from one quadrangle.[48]

This being done, I draw transversely in the quadrangle of the

picture a straight line parallel to the base line, which passes through the centric point from one side to the other and divides the quadrangle. Because this line passes through the centric point, I call it the centric line.[49] For me this line is a limit above which no visible quantity is allowed unless it is higher than the eye of the beholder. Because of this, depicted men placed in the last squared *braccia* of the painting are smaller than the others. Nature herself demonstrates to us that this is so. In temples the heads of men are seen to be almost all on the same level but the feet of the farthest correspond to the knees of the nearest. However, this rule for dividing the pavement belongs to what we shall later call composition.

[All that I have written is] such that I doubt if much will be understood by the reader, either because of the newness of the material or because of the brevity of the commentary. How difficult this is can be seen in the works of antique sculptors and painters; perhaps because it was obscure, it was hidden and unknown to them. One scarcely sees a single antique [*i*]*storia* aptly composed.[50]

Up to this point I have said useful but brief things; I believe [they are] not completely obscure. Let it be understood that I have made no attempt to capture the prize for eloquence here. He who does not understand this at the first glance will scarcely learn it no matter how much effort he applies.[51] To the subtle of wit and to those suited to painting, these our things will be facile and most beautiful no matter how they are said. To one who is rude and by nature little given to these most noble arts, these things—even if they were most eloquently written—would be unpleasing. This book should be read with care, then, because it is written without eloquence. I beg that I may be pardoned if, where I above all wish to be understood, I have given more care to making my words clear than ornate. I believe that which follows will be less tedious to the reader.

We have talked, as much as seems necessary, of triangles, pyramids, the cross-section. I usually explain these things to

my friends with certain prolix geometric demonstrations which in this commentary it seemed to me better to omit for the sake of brevity. Here I have related only the basic instructions of the art, and by instructions I mean that which will give the untrained painter the first fundamentals of how to paint well. These instructions are of such a nature that [any painter] who really understands them well both by his intellect and by his comprehension of the definition of painting will realize how useful they are. Never let it be supposed that anyone can be a good painter if he does not clearly understand what he is attempting to do. He draws the bow in vain who has nowhere to point the arrow.[52]

I hope the reader will agree that the best artist can only be one who has learned to understand the outline of the plane and all its qualities. On the contrary, anyone who has not been most diligent in understanding what we have said up to this point will never be a good artist. Therefore, these intersections and planes are necessary things. There remains to teach the painter how to follow with his hand what he has learned with his mind.

END OF BOOK ONE

Book Two

Book Two

BECAUSE this [process of] learning may perhaps appear a fatiguing thing to young people, I ought to prove here that painting is not unworthy of consuming all our time and study.

Painting contains a divine force which not only makes absent men present, as friendship is said to do,[1] but moreover makes the dead seem almost alive. Even after many centuries they are recognized with great pleasure and with great admiration for the painter. Plutarch says that Cassander, one of the captains of Alexander, trembled through all his body because he saw a portrait of his King.[2] Agesilaos, the Lacedaemonian, never permitted anyone to paint him or to represent him in sculpture; his own form so displeased him that he avoided being known by those who would come after him.[3] Thus the face of a man who is already dead certainly lives a long life through painting. Some think that painting shaped the gods who were adored by the nations. It certainly was their greatest gift to mortals, for painting is most useful to that piety[4] which joins us to the gods and keeps our souls full of religion. They say that Phidias made in Aulis a god Jove so beautiful that it considerably strengthened the religion then current.[5]

The extent to which painting contributes to the most honourable delights of the soul and to the dignified beauty of things can be clearly seen not only from other things but

especially from this: you can conceive of almost nothing so precious which is not made far richer and much more beautiful by association with painting. Ivory, gems and similar expensive things become more precious when worked by the hand of the painter. Gold worked by the art of painting outweighs an equal amount of unworked gold. If figures were made by the hand of Phidias or Praxiteles from lead itself—the lowest of metals—they would be valued more highly than silver. The painter, Zeuxis, began to give away his things because, as he said, they could not be bought.[6] He did not think it possible to come to a just price which would be satisfactory to the painter, for in painting animals he set himself up almost as a god.

Therefore, painting contains within itself this virtue that any master painter who sees his works adored will feel himself considered another god. Who can doubt that painting is the master art or at least not a small ornament of things? The architect, if I am not mistaken, takes from the painter architraves, bases, capitals, columns, façades and other similar things. All the smiths, sculptors, shops and guilds are governed by the rules and art of the painter. It is scarcely possible to find any superior art which is not concerned with painting,[7] so that whatever beauty is found can be said to be born of painting.[8] *Moreover, painting was given the highest honour by our ancestors. For, although almost all other artists were called craftsmen, the painter alone was not considered in that category.* For this reason, I say among my friends that Narcissus who was changed into a flower, according to the poets, was the inventor of painting. Since painting is already the flower of every art, the story of Narcissus is most to the point. What else can you call painting but a similar embracing with art of what is presented on the surface of the water in the fountain?

Quintilian said that the ancient painters used to circumscribe shadows cast by the sun, and from this our art has grown.[9] There are those who say that a certain Philocles, an Egyptian, and a Cleantes were among the first inventors of this art. The Egyptians affirm that painting was in use among them a good

6000 years before it was carried into Greece.[10] They say that painting was brought to us from Greece after the victory of Marcellus over Sicily.[11] But we are not interested in knowing who was the inventor of the art or the first painter, since we are not telling stories like Pliny. We are, however, building anew an art of painting about which nothing, as I see it, has been written in this age. They say that Euphranor of Isthmus wrote something about measure and about colours, that Antigonos and Xenocrates exchanged[12] something in their letters about painting, and that Apelles wrote to Pelleus about painting. Diogenes Laertius recounts that Demetrius made commentaries on painting.[13] Since all the other arts were recommended in letters by our great men, and since painting was not neglected by our Latin writers, I believe that our ancient Tuscan [ancestors] were already most expert masters in painting.

Trismegistus, an ancient writer, judged that painting and sculpture were born at the same time as religion,[14] *for thus he answered Aesclepius: mankind portrays the gods in his own image from his memories of nature and his own origins.* Who can here deny that in all things public and private, profane and religious, painting has taken all the most honourable parts to itself so that nothing has ever been so esteemed by mortals?

The incredible esteem in which painted panels have been held has been recorded. Aristides the Theban sold a single picture for one hundred talents. They say that Rhodes was not burned by King Demetrius for fear that a painting of Protogenes' should perish.[15] It could be said that the city of Rhodes was ransomed from the enemy by a single painting. Pliny[16] collected many other such things in which you can see that good painters have always been greatly honoured by all. The most noble citizens, philosophers and quite a few kings not only enjoyed painted things but also painted with their own hands. Lucius Manilius, Roman citizen, and Fabius, a most noble man, were painters. Turpilius, a Roman knight, painted at Verona. Sitedius, praetor and proconsul, acquired renown as a

painter. Pacuvius, tragic poet and nephew of the poet Ennius, painted Hercules in the Roman forum. Socrates, Plato, Metrodorus, Pyrrho were connoisseurs of painting. The emperors Nero, Valentinian, and Alexander Severus were most devoted to painting. It would be too long, however, to recount here how many princes and kings were pleased by painting. Nor does it seem necessary to me to recount all the throng of ancient painters. Their number is seen in the fact that 360 statues, part on horseback and part in chariots, were completed in four hundred days for Demetrius Phalerius, son of Phanostratus.[17] In a land in which there was such a great number of sculptors, can you believe that painters were lacking? I am certain that both these arts are related and nurtured by the same genius, painting with sculpture. But I always give higher rank to the genius of the painter because he works with more difficult things.

However, let us return to our work. Certainly the number of sculptors and painters was great in those times when princes and plebeians, learned and unlearned enjoyed painting, and when painted panels and portraits, considered the choicest booty from the provinces, were set up in the theatres. Finally L. Paulus Aemilius[18] and not a few other Roman citizens taught their sons painting along with the fine arts and the art of living piously and well. This excellent custom was frequently observed among the Greeks who, because they wished their sons to be well educated, taught them painting along with geometry and music. It was also an honour among women to know how to paint. Martia, daughter of Varro, is praised by the writers because she knew how to paint. Painting had such reputation and honour among the Greeks that laws and edicts were passed forbidding slaves to learn painting. It was certainly well that they did this, for the art of painting has always been most worthy of liberal minds and noble souls.[19]

As for me, I certainly consider a great appreciation of painting to be the best indication of a most perfect mind, even though it happens that this art is pleasing to the uneducated as

well as to the educated. It occurs rarely in any other art that what delights the experienced also moves the inexperienced. In the same way you will find that many greatly desire to be well versed in painting. Nature herself seems to delight in painting, for in the cut faces of marble she often paints centaurs and faces of bearded and curly headed kings. It is said, moreover, that in a gem from Pyrrhus all nine Muses, each with her symbol, are to be found clearly painted by nature.[20] Add to this that in no other art does it happen that both the experienced and the inexperienced of every age apply themselves so voluntarily to the learning and exercising of it. Allow me to speak of myself here. Whenever I turn to painting for my recreation, which I frequently do when I am tired of more pressing affairs, I apply myself to it with so much pleasure that I am surprised that three or four hours have passed.[21] Thus this art gives pleasure and praise to whoever is skilled in it; riches and perpetual fame to one who is master of it. Since these things are so, since painting is the best and most ancient ornament of things, worthy of free men, pleasing to learned and unlearned, I greatly encourage our studious youth to exert themselves as much as possible in painting.

Therefore, I recommend that he who is devoted to painting should learn this art. The first great care of one who seeks to obtain eminence in painting is to acquire the fame and renown of the ancients. It is useful to remember that avarice is always the enemy of virtue. Rarely can anyone given to acquisition of wealth acquire renown. I have seen many in the first flower of learning suddenly sink to money-making. As a result they acquire neither riches nor praise. However, if they had increased their talent with study, they would have easily soared into great renown. Then they would have acquired much riches and pleasure.

Enough has been said of this up to here. Let us return to our subject. Painting is divided into three parts; these divisions we have taken from nature.

Since painting strives to represent things seen, let us note in what way things are seen. First, in seeing a thing, we say it occupies a place. Here the painter, in describing this space, will say this, his guiding an outline with a line, is circumscription.

Then, looking at it again, we understand that several planes of the observed body belong together, and here the painter drawing them in their places will say that he is making a composition.

Finally, we determine more clearly the colours and qualities of the planes. Since every difference in them is born from light, we can properly call their representation the reception of light.[22]

Therefore, painting is composed of circumscription, composition and reception of light. In the following we shall treat of them most briefly.

First we will treat of circumscription. Circumscription describes the turning of the outline[23] in the painting. It is said that Parrhasius, the painter who talked with Socrates in Xenophon, was most expert in this and had examined these lines carefully. I say that in this circumscription one ought to take great pains to make these lines so fine that they can scarcely be seen. The painter Apelles used to practice this and to compete with Protogenes.[24] Because circumscription is nothing but the drawing of the outline, which when done with too apparent a line does not indicate a margin of the plane but a neat cleavage,[25] I should desire that only the movement of the outline be inscribed. To this, I insist, one must devote a great amount of practice. No composition and no reception of light can be praised where there is not also a good circumscription. It is not unusual, however, to see only a good circumscription—that is, a good drawing—which is most pleasant in itself. Here is a good aid for whoever wishes to make use of it. Nothing can be found, so I think, which is more useful than that veil which among my friends I call an intersection.[26] It is a thin veil, finely woven, dyed whatever colour pleases you and with larger threads [marking out] as many parallels as you prefer. This veil I place between the eye and the thing seen, so the visual pyramid

penetrates through the thinness of the veil. This veil can be of great use to you. Firstly, it always presents to you the same unchanged plane. Where you have placed certain limits, you quickly find the true cuspid of the pyramid. This would certainly be difficult without the intersection. You know how impossible it is to imitate a thing which does not continue to present the same appearance, for it is easier to copy painting than sculpture. You know that as the distance and the position of the centre are changed, the thing you see seems greatly altered. Therefore the veil will be, as I said, very useful to you, since it is always the same thing in the process of seeing. Secondly, you will easily be able to constitute the limits of the outline and of the planes.[27] Here in this parallel you will see the forehead, in that the nose, in another the cheeks, in this lower one the chin and all outstanding features in their place. On panels or on walls, divided into similar parallels, you will be able to put everything in its place. Finally, the veil will greatly aid you in learning how to paint when you see in it round objects and objects in relief. By these things you will be able to test with experience and judgement how very useful our veil can be to you.

Nor will I hear what some may say, that the painter should not use these things, because even though they are great aids in painting well, [they] may perhaps be so made that he will soon be able to do nothing without them.[28] I do not believe that infinite pains should be demanded of the painter, but paintings which appear in good relief and a good likeness of the subject should be expected. This I do not believe can ever be done without the use of the veil. Therefore, let us use this intersection, that is the veil, as we have said. Then, when a painter wishes to try his skill without the veil, he should note first the limits of objects within the parallels of the veil. Or he may study them in another manner by imagining a line intersected by its perpendicular wherever these limits are located. But since the outlines of the planes are frequently unknown to the inexpert

painter—doubtful and uncertain as in the faces of man where he does not discern the distance between the forehead and the temples—it would be well to teach him how he can come to understand them.

This is clearly demonstrated by nature. We see in flat planes that each one reveals itself by its lines, lights and shades. Again spherical concave planes are divided into many planes as if chequered with spots of light and shade. Therefore each part with its highlights, divided by those which are dark, would thus appear as many planes. However, if one continuous plane, beginning shadowy, becomes little by little lighter, then note the middle of it with a very fine line so that the method of colouring it will be less in doubt.

Circumscription,[29] which pertains not a little to composition, remains to be treated. For this it is well to know what composition is in painting. I say composition is that rule in painting by which the parts fit together[30] in the painted work. The greatest work of the painter is the *istoria*. Bodies are part of the *istoria*, members are parts of the bodies, planes are parts of the members. Circumscription is nothing more than a certain rule for designing[31] the outline of the planes, since some planes are small as in animals, others are large as those of buildings and colossi.

Concerning the small planes the precepts given up to here will be enough—precepts which we demonstrated when we learned how to use the veil. Perhaps we should find new rules for the larger planes. We must remember what has been said above in the instruction on planes, rays, the pyramid, the intersection, and on the parallels of the pavement, the centric point and line. On the pavement, drawn with its lines and parallels, walls and similar planes which we have called jacent are to be built. Here I will describe most briefly what I do. First I begin with the foundation. I place the width and the length of the wall in its parallels. In this laying out[32] I follow nature. I note that, in any squared body which has right angles, only two conjoined sides can be seen at one time. I observe this

in describing the foundations of the walls. I always commence first of all with the nearest plane, the greatest of those which are equidistant from the cross-section. These I put before the others, describing their width and height in those parallels of the pavement in such a way that for as many *braccia* as I choose they occupy as many parallels. To find the middle of each parallel, I find where the diameters mutually intersect. And thus, as I wish, I draw the foundations. Then the height follows by not at all difficult rules. I know the height of the wall contains in itself this proportion, that as much as it is from the place where it starts on the pavement to the centric line, so much it rises upwards. When you wish this quantity of the pavement up to the centric line to be the height of a man, there will, therefore, be these three *braccia*. Since you wish your wall to be twelve *braccia*, you go up three times the distance from the centric line to that place on the pavement.[33] With these rules we shall be able to draw all planes which have angles.

The way in which circles are drawn remains to be treated. Circles are drawn from angles. I do it in this manner. In a space I make a quadrangle with right angles, and I divide the sides of this quadrangle into parts similar to the parts of the base line of the first quadrangle in the painting. From each point to its opposite point I draw lines and thus the space is divided into many small quadrangles. Here I draw a circle as large as I want it so the lines of the small quadrangles and the lines of the circle cut each other mutually. I note all the points of this cutting; these places I mark on the parallels of the pavement in my painting. It would be an extreme and almost never-ending labour to divide the circle in many places with new minor parallels and with a great number of points to complete the circle. For this reason, when I have noted eight or more intersections, I continue the circle in the painting with my mind, guiding the lines from point to point.[34] Would it perhaps be briefer to derive it from a shadow? Certainly, if the body which made the shadow were in the middle, located by rule in its place.

We have considered in what way with the aid of the parallels the large angular and round planes are drawn. Since we have finished the circumscription, that is the way of drawing,[35] composition remains to be treated.

It would be well to repeat what composition is. Composition is that rule of painting by which the parts of the things seen fit together in the painting. The greatest work of the painter is not a colossus, but an *istoria*. *Istoria* gives greater renown to the intellect than any colossus.[36] Bodies are part of the *istoria*, members are parts of the bodies, planes part of the members. The primary parts of painting, therefore, are the planes. That grace in bodies which we call beauty is born from the composition of the planes. A face which has its planes here large and there small, here raised and there depressed—similar to the faces of old women—would be most ugly in appearance. Those faces which have the planes joined in such a way that they take shades and lights agreeably and pleasantly, and have no harshness of the relief angles, these we should certainly say are beautiful and delicate faces.

Therefore, in this composition of planes grace and beauty of things should be intensely sought for. It seems to me that there is no more certain and fitting way for one who wishes to pursue this than to take them from nature, keeping in mind in what way nature, marvellous artificer of things, has composed the planes in beautiful bodies. In imitating these it is well both to take great care and to think deeply about them and to make great use of our above-mentioned veil. When we wish to put into practice what we have learned from nature, we will always first note the limits to which we shall draw our lines.

Up to here we have talked of the composition of planes; members follow. First of all, take care that all the members are suitable.[37] They are suitable when size, function,[38] kind,[39] colour and other similar things correspond to a single beauty. If in a painting the head should be very large and the breast small, the hand ample and the foot swollen, and the body

puffed up, this composition would certainly be ugly to see. Therefore, we ought to have a certain rule for the size of the members. In this measuring it would be useful to isolate[40] each bone of the animal, on this add its muscles, then clothe all of it with its flesh.[41] Here someone will object that I have said above that the painter has only to do with things which are visible. He has a good memory. Before dressing a man we first draw him nude, then we enfold him in draperies. So in painting the nude we place first his bones and muscles which we then cover with flesh so that it is not difficult to understand where each muscle is beneath. Since nature has here carried the measurements to a mean,[42] there is not a little utility in recognizing them. Serious painters will take this task on themselves from nature. They will put as much study and work into remembering what they take from nature as they do in discovering it. A thing to remember: to measure an animate body take one of its members by which the others can be measured. Vitruvius, the architect, measured the height of man by the feet. It seems a more worthy thing to me for the other members to have reference to the head, because I have noticed as common in all men that the foot is as long as from the chin to the crown of the head. Thus one member is taken which corresponds to all the other members in such a way that none of them is non-proportional[43] to the others in length and width.

Then provide that every member can fulfil its function in what it is doing. A runner is expected to throw his hands and feet, but I prefer a philosopher while he is talking to show much more modesty than skill in fencing.[44] *The painter Demon represented hoplites in a contest so that you would say one was sweating while another, putting down his weapons, clearly seemed to be out of breath. Ulysses has been painted so that you could recognize his insanity was only feigned and not real.* An *istoria* is praised in Rome in which Meleager, a dead man, weighs down those who carry him. In every one of his members he appears completely dead—everything hangs, hands, fingers and head; everything falls heavily.[45]

Anyone who tries to express a dead body—which is certainly
most difficult—will be a good painter, if he knows how to make
each member of a body flaccid.[46] Thus, in every painting take
care that each member performs its function so that none by
the slightest articulation remains flaccid. The members of the
dead should be dead to the very nails; of live persons every
member should be alive in the smallest part. The body is said
to live when it has certain voluntary movements. It is said to be
dead when the members no longer are able to carry on the
functions of life, that is, movement and feeling. Therefore the
painter, wishing to express life in things, will make every part
in motion—but in motion he will keep loveliness and grace.
The most graceful movements and the most lively are those
which move upwards into the air.

Again we say that in composition the members ought to have
certain things in common. It would be absurd if the hands of
Helen or of Iphigenia were old and gnarled,[47] or if Nestor's
breast were youthful and his neck smooth; or Ganymede's fore-
head were wrinkled and his thighs those of a labourer; if Milo,
a very strong man, were to have soft and slender flanks; if a
figure whose face is fresh and full should have muscular arms
and fleshless hands. Anyone painting Achemenides, found by
Aeneas on the island, with the face which Virgil describes[48]
and the other members not following such consumptiveness,
would be a painter to laugh at. For this reason, all the members
ought to conform to a certain appropriateness. I should also
like the members to correspond to one colour, because it would
be little becoming for one who has a rosy, white and pleasant
face to have the breast and the other members ugly and dirty.
Therefore, in the composition of members we ought to follow
what I have said about size, function, kind and colour. Then
everything has its dignity. It would not be suitable to dress
Venus or Minerva in the rough wool cloak of a soldier;[49] it
would be the same to dress Mars or Jove in the clothes of a
woman. The antique painters took care in painting Castor

and Pollux to make them appear brothers, but in the one a pugnacious nature appeared and in the other agility. They also took pains to show under the robe of Vulcan his handicap of hobbling[50]—so great was their diligence in expressing the function, kind and dignity of whatever they painted.

The fame of the painter and of his art is found in the following—the composition of bodies. Certain things said in the composition of members also apply here. Bodies ought to harmonize together in the *istoria* in both size and function.[51] It would be absurd for one who paints the Centaurs fighting after the banquet to leave a vase of wine still standing in such tumult. [We would call] it a weakness if in the same distance one person should appear larger than another, or if dogs should be equal to horses, or better, as I frequently see, if a man is placed in a building as in a closed casket where there is scarcely room to sit down. For these reasons, all bodies should harmonize in size and in function to what is happening in the *istoria*.[52]

The *istoria* which merits both praise and admiration will be so agreeably and pleasantly attractive that it will capture the eye of whatever learned or unlearned person is looking at it and will move his soul. That which first gives pleasure in the *istoria* comes from copiousness and variety of things. In food and in music novelty and abundance please, as they are different from the old and usual. So the soul is delighted by all copiousness and variety. For this reason copiousness and variety please in painting.[53] I say that *istoria* is most copious in which in their places are mixed old, young, maidens, women, youths, young boys, fowls, small dogs, birds, horses, sheep, buildings, landscapes and all similar things. I will praise any copiousness which belongs in that *istoria*. Frequently the copiousness of the painter begets much pleasure when the beholder stands staring at all the things there. However, I prefer this copiousness to be embellished with a certain variety, yet moderate and grave with dignity and truth. I blame those painters who, where they wish

to appear copious, leave nothing vacant. It is not composition but dissolute confusion which they disseminate. There the *istoria* does not appear to aim to do something worthy but rather to be in tumult.

Perhaps solitude will be pleasing for one who greatly desires dignity in his *istoria*. The majesty of princes is said to be contained in the paucity of words with which they make their wishes known. Thus in the *istoria* a certain suitable number of bodies gives not a little dignity. Solitude displeases me in *istorie*; nor can I praise any copiousness which is without dignity.[54] *I dislike solitude in istorie, nevertheless I do not at all praise that copiousness which shrinks from dignity. I strongly approve in an istoria that which I see observed by tragic and comic poets. They tell a story with as few characters as possible. In my judgement no picture will be filled with so great a variety of things that nine or ten men are not able to act with dignity. I think pertinent to this the statement of Varro who admitted no more than nine guests to a banquet in order to avoid confusion.*

In every *istoria* variety is always pleasant. A painting in which there are bodies in many dissimilar poses is always especially pleasing. There some stand erect, planted on one foot, and show all the face with the hand high and the fingers joyous. In others the face is turned, the arms folded and the feet joined. And thus to each one is given his own action and flection of members; some are seated, others on one knee, others lying. If it is allowed here, there ought to be some nude and others part nude and part clothed in the painting; but always make use of shame and modesty. The parts of the body ugly to see and in the same way others which give little pleasure should be covered with draperies, with a few fronds or the hand.[55] The ancients[56] painted the portrait of Antigonos only from the part of the face where the eye was not lacking.[57] It is said that Pericles' head was long and ugly, for this reason he—unlike others—was portrayed by painters and sculptors wearing a helmet.[58] Plutarch says that when the ancient painters depicted

the kings, if there were some flaw in them which they did not wish to leave unnoticed, they 'corrected' it as much as they could while still keeping a likeness.

Thus I desire, as I have said, that modesty and truth should be used in every *istoria*. For this reason be careful not to repeat the same gesture or pose. The *istoria* will move the soul of the beholder when each man painted there clearly shows the movement of his own soul. It happens in nature that nothing more than herself is found capable of things like herself;[59] we weep with the weeping, laugh with the laughing, and grieve with the grieving. These movements of the soul are made known by movements of the body. Care and thought weigh so heavily that a sad person stands with his forces and feelings as if dulled, holding himself feebly and tiredly on his pallid and poorly sustained members. In the melancholy the forehead is wrinkled, the head drooping, all members fall as if tired and neglected. In the angry, because anger incites the soul, the eyes are swollen with ire and the face and all the members are burned with colour, fury adds so much boldness there.[60] In gay and happy men the movements are free and with certain pleasing inflections.[61] *They praise Euphranor since he executed the face and expression of Alexander Paris in which you could recognize him as the judge of the goddesses, the lover of Helen and the slayer of Achilles. There is also great praise for the painter Demon, since in his picture you could easily see [Paris to be] angry, unjust, inconstant, and at the same time placable, given to clemency and mercy, proud, humble and ferocious.* They say that Aristides the Theban, equal to Apelles, understood these movements very well.[62] They will certainly be understood by us when we come to know them through study and diligence.

Thus all the movements of the body should be closely observed by the painter. These he may well learn from nature, even though it is difficult to imitate the many movements of the soul. Who would ever believe who has not tried it how difficult it is to attempt to paint a laughing face only to have it

elude you so that you make it more weeping than happy? Who could ever without the greatest study express faces in which mouth, chin, eyes, cheeks, forehead and eyebrows all were in harmony with laughter or weeping. For this reason it is best to learn them from nature and always to do these things very rapidly, letting the observer think he sees more than he actually sees.

But let me say something about these movements. Part of this I fabricate out of my own mind, part I have learned from nature. First of all I think that all the bodies ought to move according to what is ordered in the *istoria*. In an *istoria* I like to see someone who admonishes and points out to us what is happening there; or beckons with his hand to see; or menaces with an angry face and with flashing eyes, so that no one should come near; or shows some danger or marvellous thing there; or invites us to weep or to laugh together with them. Thus whatever the painted persons do among themselves or with the beholder, all is pointed toward ornamenting or teaching the *istoria*. Timantes of Cyprus is praised in his panel, the Immolation of Iphigenia, with which he conquered Kolotes. He painted Calchas sad, Ulysses more sad, and in Menelaos, then, he would have exhausted his art in showing him greatly grief stricken. Not having any way in which to show the grief of the father, he threw a drape over his head and let his most bitter grief be imagined, even though it was not seen.[63] They praise the ship painted in Rome by our Tuscan painter Giotto.[64] Eleven disciples [are portrayed], all moved by fear at seeing one of their companions passing over the water. Each one expresses with his face and gesture a clear indication of a disturbed soul in such a way that there are different movements and positions in each one.

Allow me to pass over the movements most briefly. Some movements of the soul are called affections, such as grief, joy and fear, desire and other similar ones. The following are movements of the body. Bodies themselves move in several ways,

rising, descending, becoming ill, being cured and moving from place to place. We painters who wish to show the movements of the soul by movements of the body are concerned solely with the movement of change of place. Anything which moves its place can do it in seven ways: up, the first; down, the second; to the right, the third; to the left, the fourth; in depth moving closer and then away; and the seventh going around.[65] I desire all these movements in painting. Some bodies are placed towards us, others away from us, and in one body some parts appear to the observer, some drawn back, others high and others low.

Because there are some who pass all reason in these movements I should like to recount here some things about pose and movement which I have collected from nature. From this we shall clearly understand that they should be used with moderation. Remember how man in all his poses uses the entire body to support the head, heaviest member of all. When he is resting on one foot, this foot always stands perpendicularly under the head like the base of a column, and almost always in one who stands erect the face is turned in the same direction as the feet. I have noted that the movements of the head are almost always such that certain parts of the body have to sustain it as with levers, so great is its weight. Better, a member which corresponds to the weight of the head is stretched out in an opposing part like an arm of a balance. We see that when a weight is held in an extended arm with the feet together like the needle of a balance, all the other parts of the body will displace to counterbalance the weight. I have noticed that in raising the head no one turns his face higher than he would in looking at the zenith; horizontally no one can turn his face past a point where the chin touches the shoulder; the waist[66] is never twisted so much that the point of the shoulder is perpendicular above the navel. The movements of the legs and of the arms are very free in order not to hamper other 'honest' parts of the body.[67] I see in nature that the hands are almost never raised above the

head, nor the elbow over the shoulder, nor the foot above the knee, nor between one foot and the other is there more space than that of one foot. Remember that when a hand is extended upward that same side of the body even to the feet follows it so that the heel itself is raised off the pavement.

The diligent artist will note many similar things by himself. Perhaps what I have said is so obvious that it may appear superfluous. But, because I have seen not a few err in these things it seemed best not to be silent about them. You will find that in expressing too violent movements and in making the breast and the small of the back visible at the same time in the same figure—a thing which is neither possible nor becoming— some think to be praised because they hear that figures appear most lively which most throw about all their members. For this reason their figures appear hackers and actors[68] without any dignity in the painting. Because of this they are not only without grace and sweetness but moreover they show the too fiery and turbulent imagination of the artist.

The painting ought to have pleasant and graceful movements, suitable to what is happening there. The movements and poses of virgins are airy, full of simplicity with sweetness of quiet rather than strength; even though to Homer, whom Zeuxis followed, robust forms were pleasing even in women.[69] The movements of youths are light, gay, with a certain demonstration of great soul and good force. In men the movements are more adorned with firmness, with beautiful and artful poses. In the old the movements and poses are fatigued; the feet no longer support the body, and they even cling with their hands.[70] Thus each one with dignity has his own movements to express whatever movements of the soul he wishes. For the greatest disturbance of the soul there are similar great movements of the members. This rule of common movements is observed in all animate beings. It would not be fitting to give a plough ox the same movements that you would to Bucephalos, that high-spirited horse of Alexander. Perhaps it would be appropriate in

the painting to make Io,[71] who was changed into a cow, run with her tail turned straight back, with her neck erect, and her feet raised.

We have said enough about the movements of animate beings; now, then, since inanimate things move in all those manners which we have stated above, let us treat of them. I am delighted to see some movement in hair, locks of hair, branches, fronds and robes. The seven movements are especially pleasing in hair where part of it turns in spirals as if wishing to knot itself, waves in the air like flames, twines around itself like a serpent, while part rises here, part there. In the same way branches twist themselves now up, now down, now away, now near, the parts contorting themselves like ropes. Folds act in the same way, emerging like the branches from the trunk of a tree. In this they adhere to the seven movements so that no part of the cloth is bare of movement. As I have noted, movements should be moderated and sweet. They should appear graceful to the observer rather than a marvel of study. However, where we should like to find movement in the draperies, cloth is by nature heavy and falls to the earth. For this reason it would be well to place in the picture the face of the wind Zephyrus or Austrus who blows from the clouds making the draperies move in the wind. Thus you will see with what grace the bodies, where they are struck by the wind, show the nude under the draperies in suitable parts. In the other parts the draperies blown by the wind fly gracefully through the air. In this blowing in the wind the painter should take care not to display any drape against the wind.[72] All that I have said about the movements of animate and of inanimate objects I have observed. Once more you have followed with diligence what I have said about the composition of planes, members and bodies.

The reception of light remains to be treated. In the lessons above I have demonstrated at length how light has the power to vary colours. I have taught how the same colour, according

to the light and shade it receives, will alter its appearance. I have said that white and black express to the painter shade and light; all other colours for the painter are matter to which he adds more or less shadow or light. Therefore, let us leave the other things. Here we must consider solely how the painter ought to use white and black.

It is said that the antique painters Polygnotos and Timantes used only four colours. Aglaophon was marvelled at because he liked to paint with one simple colour.[73] Few of these great painters would have chosen this small number of colours, for they so valued a large number that they thought a multitude of colours more suitable to a productive artist. I certainly agree that copiousness and variety of colours greatly add to the pleasure and fame of a painting. But I should like the [highest level of attainment] in industry and art to rest, as the learned maintain, on knowing how to use black and white. It is worth all your study and diligence to know how to use these two well, because light and shade make things appear in relief. Thus white and black make painted things appear in relief and win that praise which was given to Nicias the Athenian painter. They say that Zeuxis,[74] a most famous antique painter, was almost the leader of the others in knowing the force of light and shade; little such praise was given to the others.[75] I almost always consider mediocre the painter who does not understand well the strength of every light and shade in each plane. I say the learned and the unlearned praise those faces which, as though carved, appear to issue out of the panel, and they criticize those faces in which is seen no other art than perhaps that of drawing.

I prefer a good drawing with a good composition to be well coloured. Therefore let us study first of all light and shade, and remember how one plane is brighter than another where the rays of light strike, and how, where the force of light is lacking, that same colour becomes dusky. It should also be noted that the shadow will always correspond to the light in another part

so that no part of a body is lighted without another part being dark.

As for imitating the bright with white and the shadow with black, I admonish you to take great care to know the distinct planes as each one is covered with light or shadow. This will be well enough understood by you from nature. When you know it well, with great restraint you will commence to place the white where you need it, and, at the same time, oppose it with black. With this balancing of white and black the amount of relief in objects is clearly recognized. Thus with restraint little by little continue raising more white and more black as much as you need.

A good judge for you to know is the mirror. I do not know why painted things have so much grace in the mirror. It is marvellous how every weakness in a painting is so manifestly deformed in the mirror. Therefore things taken from nature are corrected with a mirror. I have here truly recounted things which I have learned from nature.

Remember that on a flat plane the colour remains uniform in every place; in the concave and spherical planes the colour takes variations, because what is here light is there dark, in other places a median colour. This alteration of colours deceives the stupid painters, who, as we have said, think the placing of the lights to be easy when they have well designed the outlines of the planes. They should work in this way. First they should cover the plane out to the outlines as if with the lightest dew with whatever white or black they need. Then above this another and then another and thus little by little they should proceed. Where there is more light, they should use more white; where the light fails the white is lost as if in smoke. In the same way they should do the contrary with black.[76]

But remember, never make any plane so white that it cannot be made whiter. If you should dress a figure in whitest robes, it is best to stop much below the highest whiteness.[77] The painter has nothing other than white with which to show the highest

lustre of the most highly polished sword, and only black to show the deepest shadow of night. You will see the force of this by placing white next to black so that vases by this means appear of silver, of gold and of glass and appear to shine in the painting. For this reason I criticize severely all painters who use white and black without much discretion.[78]

It would please me if white were sold to painters at a price higher than the most precious gems. It would certainly be useful if white and black were made from those very large pearls which Cleopatra destroyed in vinegar, so that painters would be, as they ought to be, miserly and good managers[79] and their works would be truthful, sweet and pleasing.[80] I cannot over-emphasize the advantage of this frugality to painters. If they should perhaps sin in the distributing of black and white, it is to be held less against one who uses much black than one who does not well spread out white. From day to day follow nature so that horrid and obscure things come to be hated by you; and as in doing you learn, so your hand becomes more delicate in grace and beauty. Certainly by nature we love open and clear things; therefore, close more tightly the way in which it is most easy to sin.

We have treated of white and black. Now we will treat of the other colours, not where all good and tried colours are found like Vitruvius, the architect, but in what way well ground colours are used in painting. They say that Euphranor,[81] an ancient painter, wrote something about colours; it is not found today. Truly, if ever this was written by others, we have dug this art up from under the earth. If it was never written, we have drawn it from heaven. We will continue to use our intellect as we have up to here. I should prefer that all types and every sort[82] of colour should be seen in painting for the great delight and pleasure of the observer. Grace will be found, when one colour is greatly different from the others near it. When you paint Diana leading her troop, the robes of one nymph should be green, of another white, of another rose, of another yellow,

and thus different colours to each one, so that the clear colours are always near other different darker colours. This contrast will be beautiful where the colours are clear and bright. There is a certain friendship of colours so that one joined with another gives dignity and grace. Rose near green and sky blue gives both honour and life. White not only near ash and crocus yellow but placed near almost any other gives gladness. Dark colours stand among light with dignity and the light colours turn about among the darks. Thus, as I have said, the painter will dispose his colours.[83]

There are some who use much gold in their *istoria*. They think it gives majesty. I do not praise it. Even though one should paint Virgil's Dido whose quiver was of gold, her golden hair knotted with gold, and her purple robe girdled with pure gold, the reins of the horse and everything of gold, I should not wish gold to be used, for there is more admiration and praise for the painter who imitates the rays of gold with colours. Again we see in a plane panel with a gold ground[84] that some planes shine where they ought to be dark and are dark where they ought to be light. I say, I would not censure the other curved ornaments joined to the painting such as columns, carved bases, capitals and frontispieces even if they were of the most pure and massy gold. Even more, a well perfected *istoria* deserves ornaments of the most precious gems.

Up to here we have treated most briefly of the three parts of painting. We have treated of the circumscription, of the larger and smaller planes, we have treated of colours as we believe them to pertain to the use of the painter. Therefore, we thus express all painting when we say it is made up of these three things: circumscription, composition and the reception of light.

END OF BOOK TWO

Book Three

Book Three

SINCE there are other useful things which will make a painter such that he can attain to perfect fame, we should not omit them in this commentary. We will treat of them most briefly. I say the function of the painter is this: to describe with lines and to tint with colour on whatever panel or wall is given him similar observed planes of any body so that at a certain distance and in a certain position from the centre they appear in relief, seem to have mass and to be lifelike. The aim of painting: to give pleasure, good will and fame to the painter more than riches. If painters will follow this, their painting will hold the eyes and the soul of the observer. We have stated above how they could do this in the passages on composition and the reception of light. However, I would be delighted if the painter, in order to remember all these things well, should be a good man and learned in liberal arts. Everyone knows how much more the goodness of a man is worth than all his industry or art in acquiring the benevolence of the citizens. No one doubts that the good will of many is a great help to the artist in acquiring both fame and wealth. It often happens that the rich, moved more by amiability than by love of the arts, reward first one who is modest and good, leaving behind another

painter perhaps better in art but not so good in his habits. Therefore the painter ought to acquire many good habits— principally humanity and affability. He will thus have a firm aid against poverty in good will, the greatest aid in learning his art well.

It would please me if the painter were as learned as possible in all the liberal arts, but first of all I desire that he know geometry. I am pleased by the maxims of Pamphilos,[1] the ancient and virtuous painter from whom the young nobles began to learn to paint. He thought that no painter could paint well who did not know much geometry. Our instruction in which all the perfect absolute art of painting is explained will be easily understood by a geometrician, but one who is ignorant in geometry will not understand these or any other rules of painting. Therefore, I assert that it is necessary for the painter to learn geometry.

For their own enjoyment artists should associate with poets and orators who have many embellishments in common with painters and who have a broad knowledge of many things. These could be very useful in beautifully composing the *istoria* whose greatest praise consists in the invention. A beautiful invention has such force, as will be seen, that even without painting it is pleasing in itself alone. Invention is praised when one reads the description of Calumny which Lucian recounts was painted by Apelles.[2] I do not think it alien to our subject. I will narrate it here in order to point out to painters where they ought to be most aware and careful in their inventions. In this painting there was a man with very large ears. Near him, on either side, stood two women, one called Ignorance, the other Suspicion. Farther, on the other side, came Calumny, a woman who appeared most beautiful but seemed too crafty in the face. In her right hand she held a lighted torch, with the other hand she dragged by the hair a young man who held up his arms to heaven. There was also a man, pale, ugly, all filthy and with an iniquitous aspect, who could be compared to one who has

become thin and feverish with long fatigues on the fields of battle; he was the guide of Calumny and was called Hatred. And there were two other women, serving women of Calumny who arranged her ornaments and robes. They were called Envy and Fraud. Behind these was Penitence, a woman dressed in funereal robes, who stood as if completely dejected. Behind her followed a young girl, shameful and modest, called Truth. If this story pleased as it was being told, think how much pleasure and delight there must have been in seeing it painted by the hand of Apelles.

I should like to see those three sisters to whom Hesiod gave the names of Aglaia, Euphrosyne and Thalia, who were painted laughing and taking each other by the hand, with their clothes girdled and very clean.[3] This symbolizes liberality, since one of these sisters gives, the other receives, the third returns the benefit; these degrees ought to be in all perfect liberality. How much praise similar inventions give to the artist should be clear. Therefore I advise that each painter should make himself familiar with poets, rhetoricians and others equally well learned in letters. They will give new inventions or at least aid in beautifully composing the *istoria* through which the painter will surely acquire much praise and renown in his painting. Phidias, more famous than other painters, confessed that he had learned from Homer, the poet, how to paint Jove with much divine majesty.[4] Thus we who are more eager to learn than to acquire wealth will learn from our poets more and more things useful to painting.

However, it frequently happens that the studious and desirous of learning become tired where they do not know how to learn. Because of this, fatigue increases. For this reason we will speak of how one becomes learned in this art. Never doubt that the head and principle of this art, and thus every one of its degrees in becoming a master, ought to be taken from nature. Perfection in the art will be found with diligence, application and study.

I should like youths who first come to painting to do as those who are taught to write. We teach the latter by first separating all the forms of the letters which the ancients called elements. Then we teach the syllables, next we teach how to put together all the words. Our pupils ought to follow this rule in painting. First of all they should learn how to draw the outlines of the planes well. Here they would be exercised in the elements of painting.[5] They should learn how to join the planes together. Then they should learn each distinct form of each member and commit to memory whatever differences there may be in each member. The differences of the members are many and unclear. You will see some whose nose projects and is humped, others will have flaring simian nostrils, others pendant lips, still others the adornment of thin little lips. Thus the painter should examine every part of each member, since faces are more or less different. Again he should note that our youthful members, as can be seen, are round and delicate as if turned; in a more tried age they are harsh and angular. All these things the studious painter will know from nature, and he will consider most assiduously how each one appears. He will continually be wide awake with his eyes and mind in this investigation and work. He will remember the lap of a seated person; he will remember how graceful are the hanging legs of him who is seated; he will note in standing persons that there is no part of the body which does not know its function and its measure. It will please him not only to make all the parts true to his model but also to add beauty there; because in painting, loveliness is not less pleasing than richness. Demetrius, an antique painter, failed to obtain the ultimate praise because he was much more careful to make things similar to the natural than to the lovely.[6]

For this reason it is useful to take from every beautiful body each one of the praised parts and always strive by your diligence and study to understand and express much loveliness. This is very difficult, because complete beauties are never found in a

single body, but are rare and dispersed in many bodies. Therefore we ought to give our every care to discovering and learning beauty. It is proverbial that he who gives himself up to learning and meditating difficult things will easily apprehend the simpler.[7] Nothing is ever so difficult that study and application cannot conquer it.

In order not to waste his study and care the painter should avoid the custom of some simpletons. Presumptuous of their own intellect and without any example from nature to follow with their eyes or minds, they study by themselves to acquire fame in painting. They do not learn how to paint well, but become accustomed to their own errors. This idea of beauty,[8] which the well trained barely discern, flees from the intellect of the inexpert.

In order to make a painting which the citizens placed in the temple of Lucina near Croton, Zeuxis, the most excellent and most skilled painter of all, did not rely rashly on his own skills as every painter does today. He thought that he would not be able to find so much beauty as he was looking for in a single body, since it was not given to a single one by nature. He chose, therefore, the five most beautiful young girls from the youth of that land in order to draw from them whatever beauty is praised in a woman.[9] He was a wise painter. Frequently when there is no example from nature which they can follow, painters attempt to acquire by their own skill a reputation for beauty. Here it easily happens that the beauty which they search is never found even with much work. But they do acquire bad practices which, even when they wish, they will never be able to leave.[10] He who dares take everything he fashions from nature will make his hand so skilled that whatever he does will always appear to be drawn from nature.

The following demonstrates what the painter should seek out in nature. Where the face of some well known and worthy man is put in the *istoria*—even though there are other figures of a much more perfect art and more pleasing than this one—

that well known face will draw to itself first of all the eyes of one who looks at the *istoria*. So great is the force of anything drawn from nature. For this reason always take from nature that which you wish to paint, and always choose the most beautiful.

Take care not to do as many who learn to draw on small tablets. I prefer you to practise by drawing things large, as if equal in representation and reality. In small drawings every large weakness is easily hidden; in the large the smallest weakness is easily seen.

Galen, the doctor, writes that in his time he saw carved on a ring Phaethon drawn by four horses whose reins, breasts and feet were distinctly seen. Our painters leave this sort of fame to the sculptors of gems, for they are engaged in greater fields of praise. Anyone who knows how to paint a large figure well can easily form other small things with a single stroke. One who uses his hand and mind on these little coral necklaces and bracelets will easily err in larger things.

Some copy figures of other painters. Here they seek the praise given to Calamis, the sculptor who sculpted two cups, as is recorded, in which he copied things similarly done by Zenodorus so that no difference could be seen between them.[11] Our painters will certainly be in great error if they do not know that anyone painting—if he forces himself to represent things as he sees them in our veil—will paint things taken from nature sweetly and correctly. If perhaps you prefer to copy the works of others, because they have more patience with you than living things, it would please me more to [have you] copy a mediocre sculpture than an excellent painting. Nothing more can be acquired from paintings but the knowledge of how to imitate them; from sculpture you learn to imitate it and how to recognize and draw the lights.[12] It is very useful in evaluating the lights to squint or to close the sight with the eyelashes so that the lights are dimmed and seem painted in intersections. Perhaps it will be more useful to practise relief than drawing.

If I am not mistaken, sculpture is more certain than painting. He who does not understand the relief of the thing he paints will rarely paint it well. It is easier to find relief in sculpting than in painting. To prove that this argument is to the point: in almost every age there are some mediocre sculptors, but inept or even ridiculous painters are even more common.[13]

When you practice, always have before you some elegant and singular example, which you imitate and observe. In imitating it I think you will need to have diligence joined with quickness. Never take the pencil or brush in hand if you have not first constituted with your mind all that you have to do and how you have to do it. It will certainly be better to correct the errors with the mind than to remove them from the painting. When you acquire the habit of doing nothing without first having ordered it, you will become a much faster painter than Aesclepiodoros, who, they say, was the most rapid of all ancient painters.[14] Your mind moved and warmed by exercise gives itself with greater promptness and dispatch to the work; and that hand will proceed most rapidly which is well guided by a certain rule of the mind. If anyone should find himself a lazy artist, he will be indolent for this reason: he will try slowly and fearfully those things which he has not first made well known and clear in his mind. While he turns around among these shadows of errors like a blind man with his stick, he will probe with his brush this way and that. Therefore, never—if not with a well learned, discerning mind—never will he put hand to work.

However, since the *istoria* is the greatest work of the painter, in which there ought to be copiousness and elegance in all things, we should take care to know how to paint not only a man but also horses, dogs and all other animals and things worthy of being seen. This is necessary for making our *istoria* very copious, a thing which I have confessed to you is most important. None of the ancients agrees with my belief that one cannot be excellent in all things but only mediocre. I say,

better, I affirm, that we ought to make every effort that those things which when acquired give praise and when neglected allow censure shall not be lacking because of our negligence. Nicias, the Athenian painter, carefully painted women;[15] Heraclides was praised for painting ships; Serapion was not able to paint men, everything else he painted well; Dionysios was unable to paint anything but men; Alexander, who painted the portico of Pompeius, above all painted animals well, dogs the best; Aurelius, who was always in love, only painted goddesses, drawing in their faces the faces of those he loved; Phidias in showing the majesty of the gods gave more care to following the beauty of men; Euphranor delighted in expressing the dignity of nobles and in this he surpassed all the others.[16] Thus there were unequal faculties in each, for nature gives to each intellect its own gifts. We ought, therefore, not to be so content with them that through negligence we tire of trying to advance with our study as far as we can. The gifts of nature should be cultivated with study and exercise and thus from day to day made greater. We should pass over nothing in our negligence which can bring us praise.

When we have an *istoria* to paint, we will first think out the method and the order to make it most beautiful; we will make our drawings and models of all the *istoria* and every one of its parts first of all;[17] we will call our friends to give advice about it. We will force ourselves to have every part well thought out in our mind from the beginning, so that in the work we will know how each thing ought to be done and where located. In order to have the greatest certainty we will divide our models with parallels. In the public work we will take from our drawings just as we draw maxims and citations from our private commentaries.[18]

In making the *istoria* we should have speed of execution joined with diligence; this ought to obviate fastidiousness or tediousness of execution in us. We will avoid the urge to finish things which makes us bungle the work. Sometimes it is well

to leave the fatigue of working [to seek] recreation for the soul. It is not useful to do as some who undertake several works, beginning this one today and that one tomorrow and thus leaving them not perfected. When you begin a work make it complete in every part. There was one who showed Apelles a painting, saying, 'Today I did this.' Apelles replied to him, 'It would not surprise me if you have many others similarly done.'[19] I have seen some painters and sculptors, and even rhetoricians and poets—if there are rhetoricians and poets in this age—devote themselves to a work with zealous eagerness. Then their intellectual ardour cools off and they leave the rough and scarcely begun work to take up new things with renewed eagerness. I certainly censure such men. Anyone who wishes his things to be acceptable and pleasing to posterity should first think out thoroughly what he has to do and then with diligence perfect it. In few things is diligence prized more than intellect. But it is best to avoid the vitiating effect[20] of those who wish to eliminate every weakness and make everything too polished. In their hands the work becomes old and squeezed dry before it is finished. The ancient painter Protogenes was criticized because he did not know how to raise his hand from his panel.[21] He deserves this, because it seems to me a bizarre act of stubbornness, not one of an intelligent man. It is well to exert ourselves as much as our intellect is capable to see that by our diligence things are done well. To wish that they be more than appropriate in every respect is not possible.

Therefore, give to things a moderated diligence and take the advice of friends. In painting open yourself to whoever comes and hear everyone. The work of the painter attempts to be pleasing to the multitude; therefore do not disdain the judgement and views of the multitude when it is possible to satisfy their opinions. They say that Apelles hid behind a painting so that each one could more freely criticize it and so that he could hear their honest opinions: Thus he heard how each one blamed or praised.[22] Hence I wish our painter openly to demand

and to hear each one who judges him. This will be most useful to him in acquiring pleasantness. There is no one who does not think it an honour to pass judgement on the labours of others. It scarcely seems doubtful to me that the envious and detractors prejudice the fame of the painter. To the painter all his merits were always known, and the things which he has painted well are testimonies to his fame. Therefore, hear each one, but first of all have everything well thought out and well thrashed out with yourself. When you have heard each one, believe the most expert.

I have had these things to say of painting. If they are useful and helpful to painters, I ask only that as a reward for my pains they paint my face in their *istoria* in such a way that it seems pleasant and I may be seen a student of the art.[23] If this work is less satisfactory than your expectations, do not censure me because I had the courage to undertake such great matters. If my intellect has not been able to finish what it was praiseworthy to try, perhaps only my will ought to be praised in these great and difficult things. Perhaps someone will come after me who will correct my written errors. In this most worthy and most excellent art he may be more helpful and useful to the painters than I [have been]. If such a one does come, I beg and urge that he take up this task with a free and ready spirit, and exercise his intellect to make this noble art well governed.

However, I was pleased to seize the glory of being the first to write of this most subtle art.[24] If I have little been able to satisfy the reader, blame nature no less than me, for it imposes this law on things, that there is no art which has not had its beginnings in things full of errors. Nothing is at the same time both new born and perfect.[25]

I believe that if my successor is more studious and more capable than I he will [be able to] make painting absolute and perfect.

Finished, praise be to God, the 17th day of the month of July, 1436.

NOTES TO TEXT

Prologue, pages 39–40

1. The dedication to Gianfrancesco Gonzaga of the Latin version of the treatise published by Janitschek is derived from manuscript O. The dedication also exists in manuscripts OF, RL and NC.

2. See introduction, p. 13. See also Girolamo Mancini, *Vita di Leon Battista Alberti*, 2nd ed. (Florence, 1911), pp. 4–16.

3. Filippo: Filippo Brunelleschi (1377–1446).
Donato: Donatello (*c*. 1386–1466).
Nencio: Lorenzo (of which Nencio is the diminutive) Ghiberti (1378–1455).
Luca: Luca della Robbia (?1400–82).
Masaccio: Tommaso di Giovanni di Simone Guidi (?1400–28). Janitschek's identification of this man with the minor sculptor, Maso di Bartolommeo, called Masaccio, is no longer taken seriously.

4. *ogni laude di qual si sia virtù.*
Both *laude* and *virtù* are taken in the Latin sense used by Cicero who was frequently Alberti's source for style and terminology.

5. The building in question is the dome of Santa Maria del Fiore, started 1420, not finished till 1436. The lantern was added 1446–61. Brunelleschi's problem was to roof a drum 45.52 metres in diameter (one metre wider than the dome of St. Peter's) with the least possible expense. His solution was to point his arches in profile; thus they were able to support themselves without the aid of centring until a rather high point was

reached. The centring needed for closing the dome was easily suspended from the ribs themselves. Alberti's respect for the structure is justified; Brunelleschi's dome still dominates the Florentine territory.

6. Mallé (p. 57) reads this passage *questa mia operetta di pictura.* The manuscript actually reads *de pictura* (MI, 120r.). Since *De pictura* is the title given to Alberti's treatise in all its Latin versions, and since he is here speaking of a translation, I prefer the reading *De Pictura* and its possible reference to the original Latin version.

Book One, pages 43–59

7. *p[er] questo useremo quanto dicono piu grassa minerva* (MI, 120v.). All the Latin manuscripts contained the same phrase: *pinquiore idcirco uti aiunt minerva scribendo utemur* (O, 1r.). All further references to the Latin manuscripts will be to O which is taken as the best reading. Compare, Cicero, *De amicita*, v, 19. 'Agamus igitur pingui, ut aiunt, Minerva.' Alberti's copy of this work is still preserved in the Bibliotheca San Marco, Venice. See also Introduction, pp. 18–20.

8. *solo studia il pictore fingiere quello si vede* (MI, 120v.). The Latin varies the statement slightly to give it a more philosophic turn: *Nam ea solum imitari studet pictor quae sub luce videantur* (O, 1v.). For the painter attempts only to imitate that *which is seen in light.* (Italics mine.)

9. Mallé's reading, *al seno,* (p. 56) is apparently due to a mis-reading of the marginal notation at this point. The text reads *segnio.* A carat indicates the marginal *al[iter], seno.* My reading is borne out by all other manuscripts: P, 1v, *facto segno*: O, 1v., *facto sinu.*

10. *superficie.* Hereafter translated as plane.

11. *orlo*: rim, edge, outline, border. After this translated as outline.

Alberti is already using his concept of *la più grassa Minerva*. He is concerned primarily with form in matter. At the same time he is interested in the visible and in the external aspects of the visible. The alternate meaning of *la più grassa Minerva* is also operative in his popularization of humanist knowledge which he is now making available to artists without encumbering them with technical terms.

In content Alberti follows his source quite closely, although he reverses the logic to begin with the smallest and simplest part, building up to the more complex. His position is identical with that of the stoics as stated by Diogenes Laertius.

'Body is defined by Apollodorus in his *Physics* as that which is extended in three dimensions, length, breadth, and depth. This is also called solid body. But surface is the extremity of a solid body, or that which has length and breadth only without depth. . . . Surface exists not only in our thought but also in reality. . . . A line is the extremity of a surface or length without breadth, or that which has length alone. A point is the extremity of a line, the smallest possible mark or dot.' (Diogenes Laertius, *Lives and Opinions of Eminent Philosophers*, VII, 135. Hereafter cited as Diogenes Laertius.)

By accepting the stoic definition of the creation of solid bodies, Alberti rejects the Aristotelian refutation of that doctrine which was generally accepted in the early fifteenth century. (See Aristotle, *De caelo et mundo*, III, 1, 299a2, where the stoic belief is criticized and Pseudo-Aristotle [accepted as Aristotle until modern times], *De lineis insecabilibus*, where it is proved that since a point has no extension a series of points cannot form a line.) Alberti also avoids the definitions and terms accepted and used by his contemporary mathematicians. In the slightly later *Elementi di pittura* he clearly demonstrates that he knows these terms, but at this point he prefers to employ more usual words or terms of his own invention. This does not cause undue difficulty until he comes to the concept

of *orlo*. As a geometrician he knows that a line can have only the dimension of length, although it is still capable of separating one area from another. As a painter he knows that such a line is created from matter and as such has three dimensions. He states later in this work (p. 28) that the painter's line must be almost invisible. Because of this difficulty which he encounters in attempting to find a term to express this concept, the concept itself becomes clearer for us. In the Latin original of *Della pittura* he calls this line *ambitus* (circumference), *ora* (edge or boundary), and *fimbria* (see Macrobius, *In somnium Scipionis,* I, v–vi). In *Elementi di pittura* he is satisfied with *lembo* (edge or border) and with the Latin *discrimen* (a separation).

This search for the right shade of meaning does not indicate solely a litterateur's desire for perfection. The concepts of point, line, plane and outline, with their implication of drawing, become the basis of the artistic practice advocated in Book Two (pp. 81–3). They are fundamental to obtaining relief in painting.

12. *l'andare.* Use of the verbal noun implies motion.

13. *buccia*: skin, rind, shell.

14. Alberti is clearly referring to fluted columns common in antiquity but rare during the Middle Ages.

15. *dosso*: back.

16. This Latin variant is lacking in all the Italian manuscripts. *Nam ipsi iidem radii inter oculum atque visam superficiem intenti suapte vi ac mira quadam subtilitate pernicissime congruunt aera corporaque huiusmodi rara et lucida penetrantes quoad aliquod densum et opacum offendant quo in loco cuspide ferientes et vestigio hereant. Verum non minima fuit apud priscos disceptatio a superficie an ab oculo ipsi radii erumpant quae disceptatio sane difficilis atque apud nos admodum inutilis pretereatur* (O, fol. 2v.).

17. Free translation. *E noi qui immaginiamo i razzi quasi ess[er]e fili sottilissimi, da uno capo quasi come una mappa molto strettissimi*

legati dentro all'occhio ove siede il senso che vede et quivi, quasi come troncho di tutti razzi, quel nodo extenda drittissimi et sottillissimi suoi virgulti per sino alla opposita sup[er]ficie (MI, 121r.).

18. Alberti never makes clear his own position on the nature of sight. Frequently his statements in this text are contradictory. His reference to bodies which depart from the object for the eye would seem to make him an atomist, yet in the paragraph above he clearly states that the eye extends its rays to the plane seen. Of this much we can be sure: Alberti is aware of the more obvious properties of light. He knows that it travels in a straight line, that the angle of incidence is equal to the angle of refraction, and that light carries colour from the objects it strikes. Whether the eye emits or receives rays, it is the organ of perception.

His most fruitful innovation in the theory of vision is introduced at this point. Until Alberti's time vision was said to take the form of a cone. The stoic statement of this doctrine, derived from Euclid, bears certain similarities to Alberti. 'They [the stoics] hold that we see when the light between the visual organ and the object stretches in the form of a cone: . . . The apex of the cone in the air is at the eye, the base at the object seen. Thus the thing seen is reported to us by the medium of the air stretching out towards it, as if by a stick' (Diogenes Laertius, VII, 157). The theory of conic vision led in practice to the axial perspective of the Romans and Giotto. By substituting the pyramid for a cone Alberti made the one-point perspective system possible, for in pyramidal vision the size of the object seen varies as the height of the observer's eye and the distance to the object. Although he was physiologically incorrect, Alberti made it possible to represent objects on a plane surface with greater apparent exactitude.

19. The Latin continues here: *neque hoc loco disputandum est utrum in ipsa iunctura interioris nervi visus ut aiunt quiescat an in superficie oculi quasi in speculo animato imagines figurentur. Sed ne*

anima quidem oculorum ad visendum hoc loco munera referenda sunt. Satis enim erit his commentariis succincte quae ad rem pernecessaria sint demonstrasse (O, 3v.).

20. In the Latin Alberti is more conscientious about using his 'fatter Minerva' than in the Italian. The Latin, *eam nos n[ost]ra minerva describamus* (O, 3v.), is replaced in the Italian by, *noi la descriviamo a nostro modo* (MI, 12ʳv.).

21. *et quando sia grande vedilo che . . .*

22. The Latin contains a philosophical discussion of colour omitted from the Italian text. *Missam faciamus illam philoso-phorum disceptationem qua primi ortus colorum investigantur. Nam quid iuvat pictorem novisse quonam pacto ex rari et densi aut ex calidi et sicci frigidi humidique permixtione color extet. Neque tamen eos philosophantes aspernor qui de coloribus ita disputant ut species colorum esse numero septem statuant album atque nigrum duo colorum extrema. Unum quidem inter medium. Tum inter quodque extremum atque ipsum medium binos quod alter plus altero de extremo sapiat quasi de limite ambigentes collocant. Pictorem sane novisse sat est qui sint colores et quibus in pictura modis hisdem utendum sit. Nolim a peritioribus redargui qui dum philosophos sectantur duos tantum esse in rerum natura integros colores asserunt album et nigrum caeteros autem omnes ex duorum permixtione istorum oriri. Ego quidem ut pictor de coloribus ita sentio. Permixtionibus colorum alios oriri colores pene infinitos* (O, 4v. and 5r.).

Cf. Aristotle, *De coloribus*, 791a, as a possible source for the concept that all colours come from a mixing of white and black.

23. The source of this unusual treatment of colour is un-known to me at the present time. Pliny (*Historia naturalis*, XXXV, xxxii, 50, hereafter cited as Pliny) refers to white, yellow, red and black as the four colours used by Apelles and other painters of antiquity. The identification of these four colours with the elements is surprisingly medieval, yet Alberti may be only making his apostolic bow to tradition.

This omission of yellow from the basic colours of the painter's palette is most striking since Alberti clearly refers to yellow as a part of his colour chords (pp. 84–5 below). Filarete, who follows Alberti closely in his chapters on drawing, corrects the omission of yellow. The importance of this colour in both Trecento and Quattrocento painting is so obvious that one wonders how Alberti could have overlooked it. The key may perhaps be found in his vocabulary. When he speaks of the colour chords, yellow is rendered as *croceo* rather than the more ordinary *giallo*. This suggests saffron as the source of his yellow rather than the unstable and sometimes poisonous mineral sources described by Cennino. (Cennino Cennini, *Il libro dell'arte*, D. V. Thompson, translator and editor, New Haven, 1932–3, pp. 27–30. See also D. V. Thompson, *Materials of Medieval Painting*, New Haven, 1936, pp. 174–89.) Because experienced painters frequently encountered difficulties with yellow, Alberti may have seen fit to omit it from his palette.

In all probability Alberti was not too interested in these colours as such for he immediately turns his attention to the results of their mixing and to the observation of colour in nature. Later (pp. 84–5) they are combined as part of the colour chords.

24. *gienere* and *spetie*. Genera and species here to be taken in the biological sense.

25. In Leoni's translation this passage is rendered as the cheeks of the Virgin. It can only refer to young girls; the Italian reads *fanciulle*, the Latin *virgineas*.

26. *quell'altra bella stella Venere.* Omitted in P. The Latin renders this passage as *lucifera stella*, the morning star (O, 5v.).

27. The miracles of painting (*miracoli della pittura*) are here related to reflection, while on p. 56 of this text Alberti refers to them again in connection with placing the picture at a definite distance from the eye for the constructed space to

function properly. Sir Kenneth Clark (*Leon Battista Alberti on Painting*, London, 1944, pp. 2–3) has taken this to mean that Alberti used a *camera obscura* a full century before its invention by Della Porta. This scarcely seems possible when Alberti's statements are related to Brunelleschi's experiments in perspective, reported by Manetti, and to Alberti's experiments reported in the anonymous Life. According to Manetti, Brunelleschi painted a small panel about 12 inches square (one half *braccio*) of the Baptistry in Florence. The observer looked through a hole from the back of the panel, placed at what we now call the vanishing point, into a mirror held at arm's length. Thus both viewing point and distance were established. Alberti may be referring to this sort of 'miracle'. It is equally possible from the reference made in the anonymous Life (*Rerum it. scrip.*, Muratori, ed., XXV, cols. 299C through 300A) that Alberti had already constructed a sort of 'peepshow' in Rome before he came to Florence. This Latin Life records that 'he produced unheard-of works from this art of painting and unbelievable to those who saw them. These works he displayed in a small closed box through a tiny hole. You saw there high mountains, vast landscapes, the broad moving sea and at the same time such a long vista of distant regions that the sense of the beholder failed.' The demonstrations can only be construed with difficulty to mean a *camera obscura*, for the anonymous biographer continues 'both learned and unlearned alike swore that these were things of nature, not painted'. Apparently Alberti's 'demonstration' was similar to Brunelleschi's little panel, set in a box so the beholder was forced to look at it from the one point the construction demanded. It is not surprising that the 'sense of the beholder failed' when this small box suddenly extended to include 'distant vistas'.

28. *gravida*: pregnant.

29. *proportioni et agiugnimenti della superficiie* (MI, 122v.). Cf.

Latin: *ubi optime superficies discrimina et proportiones notarit* (O, 5v. and 6r.).

30. *dalla natura.* Cf. Latin: *natura duce.*

31. Alberti shifts from plane to solid geometry and back again with a calm and ease which may be baffling for the modern reader. He is here defining his terms. Equidistant planes or lines are those whose axis is at right angles to the observer's line of sight, and therefore parallel with the plane of the picture. In this translation *equidistant* will be reserved for solid geometry and the more familiar *parallel* used for plane geometry. Collinear planes and lines are those parallel to the line of sight but perpendicular to the picture plane. Such lines and planes are commonly called orthogonal today, that is, at right angles to the picture plane. Though parallel, they seem to meet as do the classic railroad tracks in elementary drawing books.

See also note 34, Book One.

32. Today an allusion to the proof of the similarity of triangles would accomplish the same results as Alberti's painful attempts to make this concept understandable for his fifteenth-century reader.

33. Aulus Gellius, *Noctium atticarum*, I, i, 1–3, who in turn refers to Plutarch's work on Hercules where Pythagoras is cited as the source for the size of Hercules. Hereafter cited as Aulus Gellius..

34. Most of the difficulties of this passage are due to language. The terms equidistant and collinear have already been established in the Albertian vocabulary. Equidistant quantities are not altered but represented proportionately on the cross-section. (See A below.) Collinear quantities are parallel to the line of sight. Thus only their front plane, if they have thickness, appears in the intersection. (B) The term equidistant as it is used in speaking of non-equidistant quantities refers to quantities which are neither parallel nor at right angles to the line of

sight but somewhere in between. (C) As their axis becomes more nearly parallel to the line of sight the less is seen. (D) the

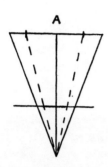 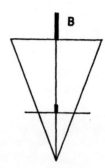

converse holds true. (C) Alberti prepared the reader for this demonstration early in Book One (see note 18).

35. *qualità.* Lapsus for *quantità.* Cf. Latin *quantitatibus* (O, 7r.).

36. With the exception of the *Laus Deo* this is the only time God is mentioned. Even so, it is used here in a colloquial expression—*così volendo Iddio,*—while in the Latin it is even further removed from the Deity—*superis ita volentibus* (O, 7v.).

37. *Aeneid,* III, 655–8; IX, 177–448.

38. *Appresso de l'Ispani molte fanciulle paiano biancose et brune* (MI, 124r.).

MI indicates the lapsus after *biancose* with a small cross. P

contains the correct reading: *E apresso agli spani multi fanciulle paiono bianchissime da appresso a germani sarebbono fusce e brune* (P, 8v.). This is corroborated by the Latin: *Apud hispanos plereq[ue] virgines candide putantur que apud germanos fusce et atri coloris haberentur* (O, 7v.).

39. Mallé corrects Janitschek's misreading of Pythagoras. Protagoras is found in all texts.

Alberti probably derived this statement from Diogenes Laertius, IX, 51. It also appears in Plato's *Theataetus*, 152A.

40. Pliny, XXXV, xxxvi, 74.

41. Latin: . . . *which to me is an open window from which the istoria is seen* (O, 8v.).

42. The Florentine *braccio* was slightly less than 23 inches.

In the Latin text the emphasis is put on the *braccio* as a unit of measurement derived from man. The measurement is not abstract but related to man in reality and in the painting. Alberti differs from Vitruvius (*De architectura*, III, i, 2) who says that man is four cubits tall.

43. *et em[m]i questa linea medesima p[ro]p[or]tionale aquella ultima quantita quale p[ri]ma mi si trav[er]so inanzi* (MI, 124v.): and to me this same line [is] proportional to that last quantity which first cut across before me. This difficult passage becomes clearer and more meaningful in the Latin: *ac mihi quidem hec ipsa iacens quadranguli linea est proximiori transverse et aeq[ue]distanti in pavimento vise quantitati proportionalis* (O, 8v.): to me this same line of the quadrangle is proportional to the nearest (or most recently mentioned) transverse and equidistant quantity seen on the pavement.

Thus the base line of the quadrangle, or painting, is directly proportional to the nearest transversal of the area seen. See note 48 for the importance of this passage.

44. This concept of observer and observed seeming to be on the same plane is most important for Alberti's aesthetic. By this means actual and represented space are seemingly one, and the

observer's identification of himself with the painting is heightened. With the addition of the effective means of painting in Book Two the link between observer and observed is forged, creating Alberti's *istoria*. See now [1966] my 'Ut rhetorica pictura,' *Journal of the Warburg and Courtauld Institutes*, XX, 26–44.

45. *Quali segniate linee amme dimostrino in che m[od]o quasi p[er] in infinito ciascuna transversa quantita segua alterandosi* (MI, 124v.). *Segua* is probably a lapsus for *sub aspectu*. I have accepted the latter reading since it appears in all Latin texts (O, 8v.).

46. I.e. exceeding by two parts. Alberti apparently refers to shop practice by which the recession of transversals could be approximated by reducing the distance between the first and second transversals by one third in order to locate the third transversal. A blank space is left in both O and OF, while NC renders it *superbi partiens,* altered by another hand to read *sub sesquatens.*

47. *diametro.*

48. Alberti's perspective construction can be briefly restated in modern terms (Diagram 1). A point, P, is determined on a

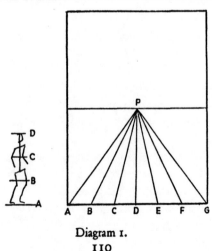

Diagram 1.

panel. The distance from the base of the panel to this point is taken as proportional to the height of a man. The height of the man to be painted is divided into thirds to form the module for the divisions of the base line, A, B, C, etc. Lines are drawn

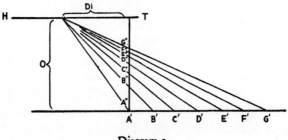

Diagram 2.

from the point P through these divisions establishing the orthogonals PA, PB, PC. In another area (diagram 2) a straight line A′, B′, C′ is drawn with the same divisions as marked on the base line of the quadrangle. Another line, HT, is drawn parallel to it and above it a distance O, equal to the distance from the centric point to the base line. On this line, the height line, the proportionate distance from the eye of the observer to the panel is established, Di. Lines are drawn from this point to the divisions A′, B′, C′. These height-distance lines are cut by a line perpendicular to the height line. The intersection of

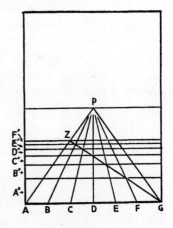

Diagram 3.

these lines with the perpendicular establishes a set of values, A″, B″, C″ which are transferred to the panel containing the orthogonals (diagram 3) to establish the recession of the

transversals. These are checked with a diagonal, GZ, which determines the accuracy of the drawing. It is to be noted that this construction makes use of two steps, one for the orthogonals and another for the transversals. In addition Alberti does not explain how he determines the distance from the eye to the plane seen, nor does he give a rule for locating the perpendicular which cuts the height-distance lines.

Although there are numerous studies of Alberti's perspective construction, the source of this construction has not been satisfactorily explained. Panofsky (*Codex Huygens*, London, 1940, pp. 93 ff., and 'Die Perspektive als "Symbolische Form"', *Vorträge der Bibliothek Warburg* (1924–5), pp. 259–61) relates the construction of orthogonals to shop practice known from the time of Ambrogio Lorenzetti's *Presentation in the Temple*. The construction of transversals he relates to Brunelleschi. This does not seem wholly acceptable. Ivins (*On the Rationalization of Sight*, New York, 1938, pp. 14–27) has a clearer understanding of Alberti's construction and advances a more credible hypothesis. According to him, the construction was built up empirically by means of a small box with peep-hole and strings from the hole to a checker-board sort of plane. Although Ivins' hypothesis is ingenious, such an empiric approach is more typical of Brunelleschi than it is of Alberti.

Whether Alberti and Brunelleschi influenced each other in their perspective constructions or whether they arrived at them separately is not of the greatest importance. Fundamentally the results are the same although the means are radically different. Manetti's *Life of Brunelleschi* (Elena Toesca, ed., Florence, 1927, pp. 9–13) supplies the source for Brunelleschi's reputation as a perspectivist. The approach as described here is basically empirical. In constructing his painting of the Baptistry Brunelleschi stood three *braccia* inside the door of Santa Maria del Fiore. It would have been possible for this doorway to serve as the frame of his picture similar to Alberti's 'window'. On

the frame of the door he could obtain sightings of the various points and angles of the building he wished to draw. His result would be a building drawn in one point perspective, but his method would differ essentially from Alberti's in that he ends with a point rather than beginning with one. Geometry does not enter into Brunelleschi's construction, for it relies solely on sightings.

Perhaps the clue to Alberti's construction can be found in his own words. At the close of Book One he states, 'I usually explain these things to my friends with certain prolix geometric demonstrations . . .' (p. 59). This phrase, taken with Alberti's insistence on the mathematics of vision, implies more geometry than experiment in his construction. Two concepts stressed in Book One may indicate the means by which he arrived at his solution. The similarity of triangles is basic to his construction; his insistence on the importance of a proper viewing point (pp. 48, 51, 56) suggests the application of the first theorem.

Between 1431 and 1434 Alberti composed in Rome a small work entitled *Descriptio urbis Romae*. It is noteworthy that this is the period when Donatello and perhaps Brunelleschi were in the city and Alberti was performing his 'miracles of painting'. In this slender volume Alberti sets forth a method for surveying and a table of sightings obtained in applying this method to the monuments of Rome. These operations have as their end what he calls a 'picture' of Rome. The instrument which he invented for this purpose is described as a bronze disc mounted parallel to the surface of the earth and divided on the circumference into 48 degrees. At the centre a metal or wooden ruler, divided into 50 degrees, is pivoted. This can be used parallel to the line of sight to obtain the bearing of the monument, and at right angles to the sight to obtain the proportionate width. When the ruler is placed at right angles to the line of sight, it becomes possible to compute the distance of the object—given its width—or its actual width—given the distance—by

means of the similarity of triangles. With such an instrument the proportionate quantities vary according to the distance of the object, a statement which frequently occurs in *Della pittura*. If one were to survey a piazza or some other rectangular planar object with this instrument (diagram 4), the proportionate of

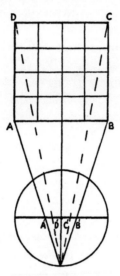

Diagram 4.

the nearer side, A'B', would appear larger than the proportionate of the farther side D'C'. If the square should be further subdivided, a greater number of readings would result in a diagram much like that used in Book Two (p. 71) to put a circle into perspective. Without the diagram one is left with a series of quantities proportionate to an object in nature. The proportionate of the nearer side must certainly be the basis for any further operation. Alberti is perhaps referring to this in his statement, 'To me this base line of the quadrangle is proportional to the nearest transverse and equidistant quantity seen on the pavement' (p. 56). From the point of view of the surveyor it would be necessary to devise a means to determine the proportionate distance between any two quantities.

There can be no doubt that Alberti understood such a method. In his *Ludi mathematici* composed for Borso d'Este about 1450 he demonstrates the well known operation of determining the width of a stream by means of a staff and the similarity of triangles. If this area should be the same piazza (diagram 5), the depth of the piazza PQ would appear pro-

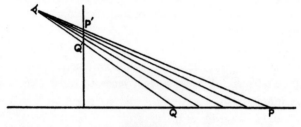

Diagram 5.

portionately on the staff as P'Q'. This latter quantity varies as the distance from the object and the height of the observer's eye—in Alberti's terms the 'distance and position of the central ray' or line of sight. The apparent recession of the other transverse quantities can be read from the staff and applied to the preceding diagram.

The theory outlined here as a source of Alberti's construction does not make use of trigonometry which had not yet been invented in his time. Since he uses the simple geometry of surveying, two steps are required to arrive at his solution. The centric ray assumes a double importance. First, as Alberti says, 'the distance and the position of the central ray are of greatest importance to the certainty of sight' (p. 48). In practice it is the point of reference; the extrinsic rays measure the quantities on the plane seen in relation to the location of the central ray or line of sight. At the same time it indicates the vanishing point in the perspective construction. If Alberti's construction derives from surveying, the apparently arbitrary location of the perpendicular cutting the height-distance lines becomes clear. For Alberti it would have been a staff held at arm's length or the

surface of the panel—in any case, the same predetermined inter-
section of the visual pyramid in both steps. His silence on the
distance from the eye to the object becomes clear from survey-
ing; he knew that the distance had to be the same in both parts
of his construction. Hence his insistence on the location of the
point of the pyramid. It is not surprising that such a system
based on the height of man, the length of his arm, and the
distance from eye to arm is expressed in terms of *braccia* and
the height of man.

Alberti is clearly presenting here an abbreviated description
of his method. Both the artists of the time and his successors
in perspective studies undoubtedly received fuller oral instruc-
tions. Some of this oral tradition reappears in Piero della
Francesca, Leonardo and Vasari in a way which further
illuminates Alberti's innovation. After describing a perspective
method essentially the same as Alberti's, Piero introduces a
second which he assures us is the same as the first (*De prospettiva
pingendi*, Giusta Nicco Fasola ed., Florence, 1942, pp. 129 ff.).
This system is based on plan and elevation drawings connected
by lines from a point of sight and cut by a perpendicular.
Essentially it is Alberti's surveying method moved indoors
to the drawing board. In all probability Vasari was best
acquainted with Piero's second method. As an architect he
readily attributed what was for him an architectural procedure
to the architect Brunelleschi (*Vite*, II, 332). Alberti's vagueness
on the location of the eye in this construction is clarified by
Leonardo. He states, 'The eye *f* and the eye *t* are one and the
same thing; but the eye *f* marks the distance, that is to say,
how far you are standing from the object; and the eye *t* shows
you the direction of it' (*The Literary Works of Leonardo da Vinci*,
J. P. and I. A. Richter (eds.), 2nd ed., London, 1939. ¶55.
Hereafter cited as R.). The accompanying diagram to this note
leaves little doubt that Leonardo was schematically combining
the two steps of Alberti's construction into one. In these con-
structions which all rely on the practice of surveying, the height

and distance of the eye from the object and the location of the intersection all remain constant. See also: M. Boskovits, 'Quello ch'e dipintori oggi dicono prospettiva,' *Acta Historiae Artium, Academiae Scientiarum Hungaricae*, 241–60, VIII (1962) and 139–62, IX (1963); Decio Gioseffi, *Prespectiva artificialis*, (Trieste, 1957); Cecil Grayson, 'L. B. Alberti's "costruzione legittima"', *Italian Studies*, XIX (1964), pp. 14–28; Richard Krautheimer, *Lorenzo Ghiberti* (Princeton, 1956), especially pp. 234–48; John White, *The Birth and Rebirth of Pictorial Space* (New York, 1958), and my review of this book in *Art Bulletin*, XLII, 225–8. See also the forthcoming Samuel Edgerton, *Alberti's Optics.*

49. This and the following sentence have been transposed from Alberti's order for reasons of clarity. The meaning has not been altered.

50. The Latin continues: *For you rarely meet with an aptly composed antique* istoria *whether painted, cast or carved* (O, 9v.).

51. Cicero, *De oratore*, III, xxiii, 80. Cicero's text is very close to Alberti's Latin.

52. *Indarno si tira larco no*[*n*] *ai da dirizzare la saepta* (MI, 125v.). *Frustra enim arcu contenditur nisi quo sagittam dirigas destinatum habeas* (O, 10r.). This aphorism is possibly derived from Cicero, *De oratore*, I, xxx, 135; *De finibus*, III, vi, 22.

Book Two, pages 63–5

1. Cicero, *De amicitia*, vii, 23. Alberti's copy of this work is still preserved at the Biblioteca San Marco, Venice.

2. Plutarch, *Life of Alexander*, LXXIV, 4.

3. Plutarch, *Life of Agesilaos*, II, 2.

4. Italian lapsus of *pietra* for *pieta* (MI, 126r.). Cf. O, 10v.: *Nam ad pietatem.*

5. Incorrectly cited as Pliny, XXXV, 62 by Mallé. The true source is unknown to me.

6. Pliny, XXV, xxxvi, 62.

7. *Ne forse troverrai arte alcuna non vilissima la quale non raguardi la pittura . . .* (MI, 126r.).

8. The Latin statement was perhaps omitted from the Italian text in order not to offend Alberti's sculptor friends Donatello and Ghiberti: *Sed et hoc in primis honore a maioribus honestata pictura est ut cum caeteri ferme omnes artifices fabri nuncuparentur solus in fabrorum numero non esset habitus* (O, 10v.).

9. Quintilian, *De institutione oratoriae*, X, ii, 7. Hereafter cited as Quintilian. Mallé unreasonably rejects Quintilian as a source in favour of Pliny, XXXV, v, 15, where a similar statement is found.

This is the only time Quintilian is mentioned by name, although Alberti draws much from him.

10. Pliny, XXXV, v, 15–16.

11. Plutarch, *Life of Marcellus*, XXI. Also Cicero, *Verrine Orations*, II, i, 21; II, iv, 54.

12. Italian lapsus. *Antigono et Xenocrate misono* . . . (MI, 126v.). Cf. Latin: *Antigonus et Xenocrate* . . . *mandasse* . . . (O, 111r.).

13. *Euphranor*: Pliny, XXXV, xl, 128, and Vitruvius, VII, pref. 14. *Antigonos and Xenocrates*: Pliny, XXXV, xxxvi, 68. *Apelles*: Pliny, XXXV, xxxvi, 111. Alberti has misread Pelleus for Perseus. *Demetrius*: Incorrectly cited as Diogenes Laertius, V, 11, by Mallé. Perhaps Diogenes Laertius, V, 83, where a painter is the fourth person listed among those named Demetrius.

14. Although Alberti quotes Hermes Trismegistus in the Latin text, it is more probable that his source was the more readily obtainable Caecilius Firmianus Lactantius, *De divinis institutionibus*, 2, 10, 3-15. In fact, Lactantius' source in the *Hermetica* (Corp. V, 6-8) says nothing about Aesclepius or about man imitating the gods.

15. *Aristides*: Pliny, XXXV, xxxvi, 100, and VII, xxxviii, 126. *Protogenes*: Pliny, XXXV, xxxvi, 105. Also Aulus Gellius, XV, xxxi, 1-5.

16. The educated patron would certainly have known the source for many of these references to Pliny. For this reason the Latin text refers *a scriptoribus* and the Italian to Pliny.

17. *Lucius Manilius*: Pliny, XXXV, vii, 23. Perhaps a misreading. L. Hostilius Mancinus is mentioned but not as a painter in Pliny. *Fabius*: Pliny, XXXV, vii, 19. *Turpilius*: Pliny, XXXV, vii, 20. *Sitedius*: Pliny, XXXV, vii, 20, where a Titedius Labeo is mentioned. *Pacuvius*: Pliny, XXXV, vii, 20. *Socrates*: Pliny, XXXV, xl, 137; XXXVI, 32. Also Diogenes Laertius, II, 19. *Plato*: Diogenes Laertius, III, 4-5. *Metrodorus*: Pliny, XXXV, xl, 135. *Pyrrho*: Diogenes Laertius, IX, 61. *Nero*: Suetonius, Life of Nero, LII, and Tacitus, Annals, XIII, 3. *Valentinian*; Ammianus Marcellinus, Rerum

gestarum, XXX, 9, 4. *Alexander Severus*: unknown to me. *Demetrius of Phalerum*: Diogenes Laertius, V, 75. Pliny, XXXIV, xii, 27, is less likely since the account is briefer than Diogenes Laertius.

18. For painting as booty see works cited in note 11, Book Two. *L. Paulus Aemilius*: Pliny, XXXV, xl, 135.

19. *Martia*: Pliny, XXXV, xl, 147. Perhaps a misreading of 'Iaia Cyzicena, perpetua virgo, M. Varronis iuventa...' Mallé (p. 80, note 2) rightly points out the tradition of a Martia as a painter throughout the Middle Ages. *Edicts*: Pliny, XXXV, xxxvi, 77.

20. Pliny, XXXVII, i, 3.

21. As indicated in the introduction (p. 15) Alberti was probably more of a dilettante than a practising artist. We do know, however, from textual sources (L. B. Alberti, 'Della tranquillità dell'animo', *Opera volgare*, Bonucci, ed., I, 26) that he made sculpture in wax and clay and perhaps cast these figures in bronze. The anonymous Life (cols. 295A–299C) refers to his 'demonstrations', to portraits in painting and sculpture done in Venice of absent Florentine friends, and to self-portraits. A plaque in bronze at the National Gallery of Art, Washington, D.C. (Kress collection, formerly Dreyfus collection, Paris), is generally regarded as a self-portrait probably executed about the time of *Della pittura*. From Vasari (II, 546–7) we know that Alberti made numerous drawings, some of which Vasari states were in his famous *Libro*. He also reports a self-portrait and a figure painting in the house of Palla Ruccellai, a perspective of Venice, and 'three storiette and several perspectives' on an altar bench in the chapel of Our Lady on the Carraia bridge in Florence which 'he has described better with the pen than the brush'. This criticism can be discounted partially because Vasari held a low opinion of Alberti's artistic work in general and because he seems to be overcome by the desire to pun on *penna* (pen) and *pennello*

(brush). A pen drawing, possibly a self-portrait, has recently been discovered (C. Grayson, 'A portrait of Leon Battista Alberti', *Burlington Magazine*, XCVI (1954), 177–8). The features are near to those of the Matteo de' Pasti medal of Alberti (Victoria and Albert Museum, London), indicating a date around 1450. The drawing is not of high quality.

22. *ricevere de lumi.*

23. *l'attorniare del orlo.*

24. *Parrhasius*: Quintilian, XII, x, 5. Pliny, XXXV, xxxvi, 67–8, cited by Mallé, does not mention Parrhasius in this connection. The source in Xenophon is *Memorabilia*, III, x, where little is said about line. Apelles and Protogenes: Pliny, XXXV, xxxvi, 81–3.

25. *fessura.* Cf. Latin: *rimule.*

26. I have omitted the Italian *quello sta cosi* and the more interesting Latin equivalent, *whose use I was the first to invent.*

27. The Latin text concludes with a phrase that puts the data gathered by the use of the veil into the practice of painting. *Another use is that they should be able in painting a panel to constitute more certainly the location of the outline and the limits of the planes* (O, 12r.).

28. This veil, or reticulated net, seems to have been adopted by painters despite current criticism of it implied by Alberti. Leonardo (R. ¶523) advocates its use as strongly as Alberti. Albrecht Dürer and Holbein the Younger made minor variations on the net for their use in drawing. In fact, Alberti's invention still appears in popular elementary drawing books. In the fifteenth century the net was probably used in conjunction with squared paper to obtain accuracy in drawing and then later transferred to panel or fresco by means of the same squares. This last step is referred to later, p. 96, and note 17 of Book Three.

29. *Intersegatione.* Lapsus for circumscription found in all Latin manuscripts.

30. *si compongano.*

31. *segniare.*

32. *descriptione.*

33. Although the text appears contradictory and unclear, it is based on Alberti's perspective construction from the end of Book One. Since the centric line is at the level of the head of a man on the front plane, it is also at the level of the head of a man on any transversal of the picture. The distance, then, from any transversal to the centric line represents one man-height or three proportional *braccia*. Since this wall is to be twelve *braccia* or four man-heights tall, it will rise three man-heights or nine *braccia* above the centric line. The distance from the transversal on which the wall rests to the centric line will give a quantity proportional to three *braccia*.

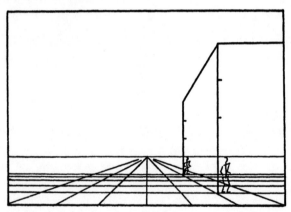

34.

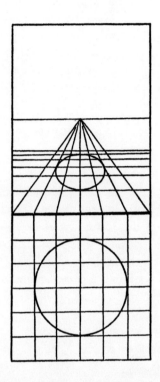

35. *disegniare.*

36. All translations and editions based on manuscript MI have gone astray at this point because of a lapsus occurring only in this text. MI reads: *Grandissimo op[er]a del pittore co[n] uno collosso ma istoria maggiore loda d'ingegnio rende l'istoria qualsia collosso* (MI, 129r.). Manuscript P corrects *con* to *non;* the Latin makes it even clearer. *Amplissimum pictoris opus non colossus sed historie. Maior enim est ingenii laus in historia q[uam] in colosso* (O, 13v.).

37. *convenire.*

38. *offitio.*

39. *spetie.*

40. *allegare.* Used here in the philosophic sense, to bring forward arguments one by one.

41. As the first to advocate the practice of building the human figure from the bones to the skin, Alberti already prefigures the anatomical researches carried on by Florentine painters in the latter half of the fifteenth century.

42. *Et paia che la natura a porto in mezzo* (MI, 129r.). The Latin is similar: *At enim cum has omnes mensura natura ipsa explicatas in medium exhibeat* (O, 14v.).

43. *non conveniente.*

44. *ma voglio un filosofo mentre che favella dimostri molto piu modestia che arte di schermire* (MI, 129v.). The Italian omits the literary reference of the Latin. *At philosophum orantem malo in omni membro sui modestiam quam palestram ostentet. Demon pictor hoplicitem in certamine expressit ut illum sudare tum quidem diceres alterumque arma deponentem ut plane anelare videretur. Fuit e qui Ulixem pingeret ut in eo non veram sed fictam et simulatam insaniam agnoscas* (O, 14v.).

Pliny, XXXV, xxxvi, 71, describes a painting by Parrhasius of hoplites and at XXXV, xl, 129, a painting by Euphranor of Ulysses.

45. *languido,* as is flaccid below.

46. In this context the Deposition for the Tabernacle of St. Peter's attributed to Donatello and dated *c.* 1433 could well be mentioned. The Christ in the relief corresponds fairly well to Alberti's description of the dead Meleager. Attempts to find the source of Alberti's description, probably drawn from a Roman sarcophagus, have not been successful.

47. *si le mani di Helena o de Efigenia fussero vecchizze et gotiche* (MI, 129v.). Cf. Latin: *aut si Helena aut Ephigenie manus senilos et rusticane* (O, 15r.).

I believe Roberto Longhi's attempts to make Alberti the first to use the word 'gothic' are somewhat extreme (Roberto

Longhi, 'Il "Maestro di Pratovecchio"', *Paragone*, (1952), p. 15 and note). I prefer to read the Italian *gotiche* as gouty and the Latin *rusticane* as rustic, rough or pertaining to country folk. I have it on good medical authority that gout, when it strikes the hands, leaves them rough and swollen. If it is possible to equate rustic with gothic, Longhi's reading may be acceptable.

48. Aeneid, III, 588–615.

49. *capperone da sacomanno*. In the fifteenth century *sacomanno* is used by Vespasiano da Bisticci in his *Lives* to describe the looters and foragers of an army. The Latin makes Alberti's sense even clearer: *Nam venerem aut minerva saga inductam esse* (O, 15r.). The *sagum* was a rough wool cloak symbolic of war as the toga was of peace. *In sagus esse* was used as indicative of being under arms. Although Minerva was not infrequently portrayed in armour, the rough cloak of a soldier would have been somewhat out of character.

50. Cicero, *De natura deorum*, I, xxx.

51. *adoperarsi*. Latin: *officio*.

52. Centaurs appear rather late in fifteenth century Florentine painting as, for example, in the paintings of Pollaiuolo, 'Rape of Dejanira', Jarves Collection, Yale University; Botticelli, 'Pallas and the Centaur', Uffizi; Piero di Cosimo, 'Battle of Centaurs and Lapiths', National Gallery, London.

The 'man in the box' is more typical of the criticism levelled at Italian Trecento painting, although it could apply just as well to the paintings of France and the Low Countries at the time of Alberti's trip to the north.

53. See introduction, pp. 26–7.

54. The Italian version omits this variant found in all Latin manuscripts. *Odi solitudinem in historia tamen copiam minime laudo que a dignitate abhorreat. Atque in historia id vehementer approbo quod a poetis tragicis atque comicis observatum video ut quam possint paucis personatis fabulam doceant. Meo quidem iuditio nulla erit usque adeo*

tanta rerum varietate refercta historia quam ix aut x homines non possint indigne agere ut illud Varronis huc pertinere arbitror qui in convivio tumultum evitans non plusque novem accubantes admittebat (O, 16r.).

The statement by Varro is derived from Aulus Gellius, XIII, xi, 1–3.

55. In this passage as in many others Alberti must be read in the context of his historical moment. Although the movements he advocates may seem violent and too varied for our taste, he was almost forced to overstate his position in order to persuade both painter and patron to reject the frozen hieratic figures of Trecento painting. In order to obtain a little vitality and movement he had to ask for much.

Botticelli is perhaps most frequently evoked by this passage, yet the movements of Piero della Francesca's 'Death of Adam' or of Ghiberti's 'Jacob and Esau' and 'Joseph' panels are closer in spirit to the art of this treatise.

Manuscript NC (14v.) adds a marginal note in another hand citing the actions of Ulysses who covered his nudity with branches before addressing Nausicaa.

56. *li antiqui.* Latin: *Apelles.*

57. Pliny, XXXV, xxxvi, 90, and Quintilian, II, xiii, 12.
This mention of a one-eyed soldier whose lack of an eye was skilfully concealed by painters suggests Federigo da Montefeltro. In all probability the artists' method of portraying Federigo who lost an eye in 1450 was suggested by this text.

58. Plutarch, *Life of Pericles*, III, 2. Pliny, XXXV, 137, seems less likely as a source.

59. Cicero, *De amicitia*, xiv, 50. Alberti's Latin is very close to Cicero. See also Horace, *De arte poetica*, 101–3.

60. Seneca, *De ira*, I, i, 3–6.

61. The Latin variant is derived from Pliny's description (XXXIV, xix, 77) of Euphranor's statue of Paris: *Laudatur*

Euphranor qui in Alexandro Paride vultus et faciem effecerit in qua illum et iudicem dearum et amatorem Helene et una Achillis interfectorem possis agnoscere. Est et Demonis quoque pictoris mirifica laus quia in eius pictura adesse iracundum iniustum inconstantem unaque et exorabilem et clementem misericordem gloriosum humilem ferocemque facile intelligas (O, 16v.). The source for the description of the painting by Demon is unknown to me.

62. Pliny, XXXV, xxxvi, 96–100.

63. Kolotes is referred to in the Italian version as Colocentrio, in the Latin as Colloteicum. Alberti probably formed one word from Coloten Teium as it appears in Quintilian. Pliny mentions that the story was praised by orators; these orators, Cicero and Quintilian, are more probably Alberti's source than Pliny's brief description of the painting. Quintilian, II, xiii, 13. Cicero, *Orator*, xxii, 74. Pliny, XXXV, xxxvi, 73–4.

64. Giotto's mosaic, 'the Navicella', over the entrance to Old St. Peter's, where Alberti knew it. The mosaic has since been moved several times and much restored. See Introduction, p. 25.

65. Quintilian, XI, iii, 105, discusses seven significant motions similar to these.

66. zenith: *quando vegga in mezza il cielo.* Horizontally: *in lato.* waist: *ove ti cigni.*

67. Free translation derived from both Italian and Latin. *I movimenti delle gambe et delle braccie sono molto liberi ma non vorrai io coprisero alcuna degnia et honesta parte del corpo* (MI, 131v.). *Tibiarum et brachi[orum] motus liberiores sunt. Modo caeteras corporis honestas partes non impediant* (O, 19r.).

68. *schermidori et istrioni.*

69. Quintilian, XII, x, 5. Not in Pliny, XXXV, 64, as cited by Mallé.

70. This difficult sentence in the Italian is translated with the

help of the Latin: *All movements in the old are sluggish and they are supported in their posture as if the body is not held up by both feet but they even cling with their hands* (O, 19v.).

71. MI originally read *Niobe*, which has been rasured and *Io* substituted above it. The Latin text assumes greater classical knowledge on the part of the reader, for it refers to Io solely as *celebrem illam Inachi filiam* (O, 19v.).

72. This discussion of inanimate movement grows logically out of the passage on animate movement; one cannot exist without the other. Sir Kenneth Clark (*Alberti on Painting*, p. 18) and John Pope-Hennessy (*Paolo Uccello*, London and New York, 1950, p. 17) have already indicated Uccello's Flood as one of the best examples of Alberti's inanimate movement. In this fresco hair, branches and draperies move in the wind issuing from a wind god in the upper right corner of the painting. Many of the poses, gestures and the presence of nudes and half-nudes advocated by Alberti appear here. At the same time, Uccello's failure to use correctly the simplest part of Alberti's theory, the perspective construction, casts some doubt on the influence of the treatise on this painter. Botticelli's Birth of Venus is perhaps the best known Quattrocento painting to include wind gods to agitate draperies. Many of these inanimate movements, either singly or in groups, appear frequently in fifteenth-century Florentine painting.

73. Cicero, *De Brute*, xviii, 70, names Zeuxis, Polygnotus and Timantes as painters who used four colours. Quintilian, XII, x, 3, praises Polygnotus and Aglaophon for their simple colouring. Pliny, XXXV, xxxii, 50, cites Apelles, Aetion, Melanthius and Nicomachus as painters employing four colours.

74. Nicias: Pliny, XXXV, xl, 131. Zeuxis: Quintilian, XII, x, 4.

75. Probably from Quintilian, XII, x, 3.

76. This discussion has its basis in the opening pages of the treatise where Alberti treats of the construction of planes from

lines. This almost geometric construction of points, lines and planes is accepted into the practice of painting in a way that distinguishes much Renaissance underpainting from that of the Middle Ages. Although Cennino advocates the use of washes in drawing and, to a certain extent, in underpainting, Trecento practice seems to have preferred hatching to obtain modelling. Instead of the complex hatching with colour, the painter is now to use subtle gradations from white to black in the underpainting to obtain a greater feeling of relief. In effect this method brings the pen and ink drawing on the prepared ground up into the paint film.

We have already seen the importance of the plane as the basic unit of all forms in Alberti's aesthetic. The effect of light on colour and in making things visible is of an equal importance. Logic demands that these two be combined; light as it strikes the plane makes the plane visible and also affects the colour on the plane. Black and white have already been established as the painter's means of representing greater or lesser degrees of light; therefore, these black and white washes represent the effects of light, thus giving relief to the plane and to the body of which the plane is a part.

This concept was probably derived from the practice of Masaccio. Such modelling can be clearly seen in the Christ child of his Madonna at the National Gallery, London.

77. In this case the Latin is clearer than the Italian derived from it. *Thus in painting white clothing it is useful to use one of the four genera of colours, so that it will be open and clear. And the contrary, in painting a black robe we take up the other extreme which is not far from the shadow, for example, the colour of the deep and dark sea* (O, 20r.).

78. *senza molto modo*. Cf. Latin: *indiligenter*.

79. *massai*: manager of country house and/or farm tools. By extension any manager. *Masseritia*, translated here as frugality, is derived from *massai*.

80. The Latin continues, *Here Zeuxis, the painter, usually criticized those who did not know what was extreme* (O, 20v.).

81. Vitruvius, VII, vii–xiv. *Euphranor*: Pliny, XXXV, xl, 129.

82. *genera et spetie.*

83. In this section Alberti is no longer considering colour abstractly or empirically as he did in Book One (pp. 49–50). Nor is he concerned with the mineral sources of the artist's colours and their preparation. His interest is now turned to the affective value of colours in combination. In this he is the first to treat of the psychological effects of colour both to arouse emotions in the observer and to create a sense of vivacity and movement. Colour now goes hand in hand with gesture, the commentator and the perspective construction to create a sense of identification between the observer and the painting.

The colour chords themselves seem rather unusual. There is no precedent for them in Trecento painting, and Masaccio's Carmine frescoes are so covered with soot that it is impossible to know what his palette may have been. It is clear, however, that both Domenico Veneziano in his 'St. Lucy altarpiece' and Piero della Francesca in his Arezzo frescoes are strong advocates of the Albertian colour system.

84. Read by Janitschek *una piana tavola ove sia loro*; corrected by Mallé to *ove sia l'oro*. Correction verified by Latin text *in plana tabula auro* (O, 21r.).

Alberti's strong condemnation of gold ground in painting should not be unexpected. The art characterized by *Della pittura* uses light rationally to model form. Such an art cannot allow burnished and tooled gold to negate the modelling by its own lights and darks.

1. Pliny, XXXV, xxxvi, 77.

2. Lucian, *De calumnia*, 5. This famous episode was known throughout antiquity. Although Alberti may have known Greek, this dialogue already existed in at least three translations prior to 1435, by Guarino Guarini of Verona, dated probably between 1406 and 1408; by Alberti's schoolmate at Padua, Filelfo, before 1428; and by Lapo di Castiglionchio around 1435. For a fuller discussion see Rudolph Altrocchi, 'The Calumny of Apelles in the Literature of the Quattrocento', *PMLA*, 36 (1921), pp. 454–91. See also Erwin Panofsky, *Studies in Iconology* (New York, 1939), p. 158, note 100, for an interesting discussion of Alberti's transformation of this text and its effect on subsequent art.

3. Although this is one of the earliest references to the concept of cleanliness, a new concept in the Renaissance, both the Latin text and the source of this description characterize the robes of the Graces, for symbolic reasons, as transparent rather than clean. Alberti's source, Seneca, *De beneficiis*, I, iii, 2–7, explains the allegory in this fashion. 'Some would have it that there is one [Grace] for bestowing a benefit, another for receiving it and a third for returning it; others hold that there are three classes of benefactors—those who earn benefits, those who return them, those who receive and return them at the same time. The sisters dance in a ring for the reason that a benefit passing in its course from hand to hand returns nevertheless to

the giver; the beauty of the whole is destroyed if the course is anywhere broken.'

See also Strabo, *Geography*, IX, ii, 40, for a similar discussion.

4. Strabo, *Geography*, VIII, iii, 30 (C354). Homer is cited. Although Alberti advocates throughout this passage an exchange of ideas between poets and painters, it seems scarcely possible, in the light of the theory of painting he has been developing up to this point, that he wishes an art of illustration. *Ut poesis pictura* would not seem to apply to the art presented in *Della pittura*.

5. Quintilian, I, i, 35, refers to elements in this fashion. Alberti's aim in this passage is quite clear. The painter should advance from simple to complex just as he does in learning to write. In general terms Alberti sketches out the course of study for the painter who is either just beginning or who wishes to improve his art. The suggestion that the artist should learn the parts before attempting to depict the whole came to mean in the academies that one should spend years drawing the parts of the human body from casts before approaching the model.

The implications of this passage, however, go far beyond academic rules. By referring to 'elements of painting' Alberti seems to suggest that there is more to painting than careful study of the parts of the human body. A few years after *Della pittura* he composed a book which could be called a 'mathematics for painters'. In this book he redefines the geometry basic to *Della pittura* and then gives the painter a series of exercises in composing geometric forms. This work he titled *Elements of Painting (Elementi di pittura)*. The implication, then, is that geometry lies at the base of all composition; not only of the planes that make up the figures but of the whole panel as well. Such does prove to be the case in several well known paintings. Masaccio's Trinity is based on a square in which the

crucified Christ resembles the man in the square of Vitruvius and Leonardo. This square becomes the module for 1 : 1, 1 : 2, 2 : 3, 3 : 4 relationships which govern the composition of the fresco. At least two painters after 1436 make use of a geometric organization of the painting surface. Domenico Veneziano seems to work variations on golden section rectangles and triangles in his St. Lucy altarpiece in the Uffizi; Piero della Francesca employs a rectangle based on one to the square root of two in his Flagellation at Urbino and in the Queen of Sheba and Testing of the Cross frescoes at Arezzo. Logically such an organization follows from the early Renaissance reliance on mathematics to control the data of the visible world. It is not a difficult step from the geometry of space and the human figure to the geometry of surface composition.

6. Quintilian, XII, x, 9.

7. The Latin is more clearly stated, *Nam qui graviora apprehendere et versare didicerit is facile minora poterit ex sententia* (O, 23r.), and is closer to Alberti's source, Cicero, *De oratore*, II, xvi, 69–70.

8. This is the only time the word *idea* appears in the treatise. Previously (p. 72) Alberti referred to 'a type of beauty', but only here to an idea of beauty. The appearance of the word may be taken to indicate that Alberti was already a Neo-platonist. If such is the case, then Alberti's model and source for many of his concepts is also a Neo-platonist, for Cicero (*Orator*, ii, 8–10) develops a fuller discussion of the Platonic *eidos* and its relation to beauty.

Alberti's concept of beauty is never clear. His best known definition of beauty (*De re aedificatoria*, VI, ii) as such a harmonious whole that nothing can be added, taken away or changed without destroying it was not formulated until much later in life. Interestingly enough this definition in the treatise on architecture is followed almost immediately by a reference to Cicero as 'that student of the beautiful'. In *Della pittura*

Alberti's position is ambiguous. His reference to Zeuxis may indicate that we are to search out the residue of the Ideal beauty in numerous examples in order to come to a better understanding of the true Idea. Since his citation is drawn from Cicero, it seems more likely that Alberti is here continuing the concept expressed earlier of knowledge derived from comparison.

9. Cicero, *De inventione*, II, i, 1–3. Cicero seems preferable as a source to Pliny, XXXV, xxxvi, 64.

10. Cicero, *De oratore*, I, xxxiii, 149–50, says the same thing about the beginning orator.

11. Pliny, XXXIV, xviii, 47, where Zenodorus is cited as copying cups by Calamis.

12. The normal medieval shop practice as reported by Cennino Cennini (*Libro dell'arte*, pp. 14–15) required the apprentice painter to copy the work of one master in order to acquire skill in painting. Alberti rejects this practice because it teaches to copy but not to compose. He prefers the artist to learn from nature, the source of all knowledge, rather than from a master. In the words of Leonardo, 'he who can go to the fountain does not go to the water-jar' (R. ¶490. See also R. ¶484–5). The suggestion of drawing from sculpture is valuable in itself. The necessary distillation of the essentials in the human figure accomplished by the sculptor will greatly simplify the task of the beginner. Unfortunately, Alberti could not know the excesses of academic practice which were to derive from this suggestion.

13. *Sia questo argomento acto quanto veggiamo che quasi in ogni betà sono stati alcuni mediocri sculptori ma truovi quasi niuno pictore non in tutto di riderlo et disadatto* (MI, 135r.). This phrase is followed in the Latin by *in brief, study to be a painter or a sculptor* (O, 24v.).

14. Pliny, XXXV, xxxvi, 109, refers to Nichomachus as a rapid painter. Since the passage on Nichomachus follows a

discussion of Aesclepiodoros it is possible that Alberti either misread or had a copy with a lapsus at this point.

15. The Italian omits *and Zeuxis was superior to many others in the painting of the bodies of women* (O, 24v.).

16. *Nicias*: Pliny, XXXV, xl, 130. *Heraclides*: Pliny, XXXV, xl, 135. *Serapion*: Pliny, XXXV, xxxvii, 113. *Dionysios*: Pliny, *loc. cit. Alexander*: possibly a misinterpretation of Pliny, XXXV, xl, 132. *Aurelius*: Pliny, XXXV, xxxvii, 119. *Phidias*: unknown to me. *Euphranor*: Pliny, XXXV, 128.

17. The translation is here based essentially on the Latin: *Modulosque in cartis coniicientes tum totam historiam tum singulas eiusdem historie partes commentabimur* (O, 24v.).

18. Alberti's meaning in this passage is not wholly clear. A difficult concept is further complicated by Vulgar Latin forms of words used in a restricted sense by lawyers. Similar passages in *De re aedificatoria* (VIII, ix) and in *Della tranquillità dell'animo* (Bonucci ed., I, 93) demonstrate the importance of this concept for Alberti and aid the translation of the present text.

The Latin reads: *Quove id certius teneamus modulos in paralellos dividere iuvabit ut in publico opere cuncta veluti ex privatis commentariis ducta suis sedibus collocentur* (O, 24v.). 'In order that we may have a more certain idea [of it], it will help to divide the modules into parallels in order that in the public work everything may be ordered in its proper place as though drawn from private notebooks.' The thought of a literary man who draws quotations from works in his library in order to recast them into a new literary whole is obvious in this passage. The artist is to do the same. He will take from his drawings as the litterateur takes from his notes to construct a new and original whole.

The practice of squaring a drawing which is to be transferred to a larger painting can be seen in the Uccello drawing of Sir John Hawkwood in the Uffizi and on the surface of Masaccio's Trinity in Santa Maria Novella.

19. Plutarch, *De liberis educandis*, 7.

20. *decimaggine*, for which I have found no suitable translation. I use instead the Latin *sed vitanda est* (O, 25r.).

21. Pliny, XXXV, xxxvi, 80.

22. Pliny, XXXV, xxxvi, 84.

23. There are only three known fifteenth-century portraits of Alberti, and none of these occurs in painting. The Matteo de' Pasti medal, the self-portrait plaque and the Vatican ink drawing cited above. It is possible that unrecognized portraits of Alberti do exist, or that they may have existed and are now lost. The phrasing of the sentence seems to suggest that Alberti expected his portrait to appear in the near future.

24. This sentence is derived from the Latin (O, 25v.) which is more in keeping with the context of the remainder of the passage than is the weaker and more confused Italian. *Noi pero ci reputeremo ad volupta primi avere presa questa palma, d'avere ardito commendare alle lettere queste arte sottilissima et nobilissima* (MI, 136r. and 136v.).

25. Cicero, *De Brute*, xviii, 71.

INDEX

Achemenides, 74
Achilles, 77, 127
Aemilius, L. Paulus, 66, 120
Aeneas, 55, 74
Aeneid, 108, 125
Aesclepiodoros, 95, 135
Aesclepius, 65, 119
Aetion, 128
Agesilaos, 63
Aglaia, 91
Aglaophon, 82, 128
Albergati, Nicholas, 14
Alberti, Benedetto, 13
Alberti, Carlo, 13
Alberti, Leon Battista, as artist, 15,
 51, 55, 67, 70-1, 77-8
 works—see under title
Alberti, Lorenzo, 13
Alexander, 63, 80
Alexander (painter), 96, 135
Alexander Severus, 66, 120
De amicitia, 100, 118, 126
Ammianus Marcellinus, 119
Angelico, Fra, 30, 32
Antaeus, 53
Antigonos, 65, 76, 119
Apelles, 65, 68, 77, 90, 91, 97, 104,
 119, 121, 126, 128
Apollodorus, 101
De architectura, 109, 130
Arezzo, San Francesco, 31, 130, 133

Aristides the Theban, 65, 77, 119
Aristotle, 16, 101, 104
De arte poetica, 38, 126
Aulus Gellius, 53, 107, 119, 126
Aurelius, 96, 135
Austrus, 81

Barzizza, Gasparino, 13, 16
Beauty, 92-3, 133-4
De beneficiis, 131
Bonucci, Anicio, 34, 35, 37, 120,
 135
Botticelli, Sandro, 31, 125, 126, 128
Brunelleschi, Filippo, 14, 15, 21, 28,
 39, 40, 99, 100, 106, 112, 113,
 116
De Brute, 128, 136
Bucephalos, 80

De caelo et mundo, 101
Calamis, 94, 134
Calchas, 78
De calumnia, 131
Calumny of Apelles, 25, 90, 131
Cassander, 63
Castagno, Andrea, 31, 110
Castiglionchio, Lapo di, 131
Castor, 74
Cennini, Cennino, 11, 105, 129,
 134
Centaurs, 75, 125

Index

Cicero, 17, 18, 25, 99, 100, 117, 118, 119, 125, 126, 127, 128, 133, 134, 136

Circumscription, 68

Cleantes, 64

Cleopatra, 84

Colloteicum, 127

Colocentrio, 127

De coloribus, 104

Coloten Teium, 127

Colour, 49-51, 84-5, 104-5, 130

Composition, 68, 72

Copying, 94-5

Croton, 93

Cusa, Nicholas of, 16

Cyclops, 55

Death of Meleager, 25, 73-4

Demetrius, 65, 92, 119

Demetrius, King, 65

Demetrius Phalerius, 66, 120

Demon, 73, 77, 127

Descriptio urbis Romae, 113

Diana, 84

Dido, 85

Dignity, 26, 74-6, 80

Diogenes Laertius, 65, 101, 103, 109, 119, 120

Dionysios, 96, 135

De divinis institutionibus, 119

Domenico Veneziano, 30, 31, 110, 130, 133

Donatello, 14, 15, 28, 39, 40, 99, 113, 118, 124

Donato—see Donatello

Drawing, 82, 94

Dürer, Albrecht, 121

Elementi di pittura, 19, 38, 101, 102, 132

Emotion, projection of, 24-6, 77-8

Ennius, 66

Euclid, 103

Eugene IV, Pope, 14

Euphranor, 65, 77, 96, 119, 124, 126, 127, 130, 135

Euphrosyne, 91

Euryalus, 55

Evander, 53

Fabius, 65, 119

Della famiglia, 12, 15, 17

Federigo da Montefeltro, 126

Filarete, 12, 105

Filelfo, 131

Filippo—see Brunelleschi

Florence, Baptistry, 14, 106, 112

Carmine, 130

Cathedral (Santa Maria del Fiore), 14, 99, 112

Sant'Egidio, 30

San Lorenzo, 14

San Marco, 30

Santa Maria Novella, 132, 135

Or San Michele, 14

Function, 73-4

Galen, 94

Ganymede, 55, 74

Geography, 132

Ghiberti, Lorenzo, 14, 28, 39, 99, 118, 126

Giotto, 25, 78, 103, 127

God, 54, 98, 108

Gold in painting, 85

Gonzaga, Gianfrancesco, 28, 99

Guarini, Guarino, 131

Helen, 74, 77, 124, 127

Heraclides, 96, 135

Hercules, 53, 66, 107

Hermetica, 119

Hesiod, 91
Hogarth, William, 12
Holbein the Younger, Hans, 121
Homer, 80, 91, 132
Horace, 25, 38, 126

Immolation of Iphigenia, 25, 78
De institutione oratoriae, 118, 121,
 126, 127, 128, 132, 133
Invention, 90-1
De inventione, 134
Io, 81, 128
Iphigenia, 74, 124
 See also Immolation of
De Ira, 126
Istoria, 23-8, 58, 70, 72-3, 75-8, 85,
 90, 93, 95, 96, 98, 110, 117, 123,
 125

Janitschek, Hubert, 34, 35, 99, 109,
 130
Jove, 26, 63, 74, 91

Kolotes, 78, 127

Lactantius, Caecilius Firmianus, 119
Landino, Cristoforo, 16
Leonardo da Vinci, 12, 23, 31, 116,
 121, 133, 134
Leoni, 12, 35, 105
De liberis educandis, 135
Libro dell'arte, 11, 105, 134
Life of Agesilaos, 118
Life of Alexander, 118
Life of Marcellus, 119
Life of Nero, 119
Life of Pericles, 126
Line, 43-5, 68, 89, 101-2, 107-8,
 129
De lineis insecabilibus, 101

Lippi, Fra Filippo, 30
Lorenzetti, Ambrogio, 112
Luca—see Robbia, Luca della
Lucian, 90, 131
Lucina, temple of, 93
Ludi mathematici, 115

Mallé, Luigi, 34, 35, 100, 109, 118,
 119, 120, 121, 127, 130
Mancini, Girolamo, 37, 38, 99
Mancinus, L. Hostilius, 119
Manetti, 106, 112
Manilius, Lucius, 65, 119
Mantegna, Andrea, 110
Marcellus, 65, 119
Mars, 26, 74
Martia, 66, 120
Masaccio, 14, 15, 28, 29, 31, 39, 99,
 129, 130, 132
Maso di Bartolommeo, 99
Mathematics, 21-3, 43-5
Medici, Cosimo de', 30
Melanthius, 128
Meleager, 73, 124
 See also Death of
Memorabilia, 121
Menelaos, 78
Metrodorus, 66, 119
Milo, 74
Minerva, 26, 74, 125
Minerva, la più grassa, 18-20, 43,
 100, 104
Mirror, 83
Modelling, see reception of light
Movement, animate, 23, 76, 78-81,
 126
 inanimate, 81, 128

Nanni di Banco, 14
Narcissus, 64
De natura deorum, 125

Nature as artist, 67
Nausicaa, 126
Nencio—see Ghiberti
Nero, 66, 119
Nestor, 74
Nicias, 82, 96, 128, 135
Nicomachus, 128, 134
Niobe, 128
Nisus, 55
Noctium atticarum, 107, 119, 126
Nude, the, 73, 76

Ockham, William of, 16
Orator, 127, 133
De oratore, 117, 133, 134

Pacuvius, 65, 119
Painter, education of, 89–90, 92 ff.
 function of, 89
Painting, aim of, 89
 primacy of, 64, 66
 origins of, 64–5
Pamphilos, 90
Paris, 77, 126, 127
Parrhasius, 68, 121, 124
Pasti, Matteo de', 121, 136
Pelleus, 65, 119
Pericles, 76
Perseus, 119
Perspective construction, 19, 21, 23, 56–8, 70–1
Phaethon, 94
Phidias, 20, 63, 64, 91, 96, 135
Philocles, 64
Piero della Francesca, 12, 31, 32, 110, 116, 126, 130, 133
Piero di Cosimo, 125
Pippo, see Brunelleschi
Plane, 19, 44–5, 47–8, 52, 54, 68–70, 72, 82–3, 92
Plato, 66, 109, 119

Pliny, 65, 104, 109, 118, 119, 120, 121, 124, 126, 127, 128, 130, 131, 134, 135, 136
Plutarch, 63, 76, 107, 118, 119, 126, 135
Point, 19, 43
Pollaiuolo, Antonio, 31, 125
Pollux, 75
Polygnotos, 82, 128
Polyphemus, 55
Pompeius, portico of, 96
Praxiteles, 20, 64
Proportion, 17, 22, 73
De prospective pingendi, 116
Protagoras, 17, 55, 109
Protogenes, 65, 68, 97, 119, 121
Pyramid, visual, 47–8, 53–4
 intersection of, 52–4, 68–70, 107–8, 121
Pyrrho, 66, 119
Pythagoras, 107, 109

Quintilian, 64, 118, 121, 126, 127, 128, 132, 133

Raphael, 31
De re aedificatoria, 12, 14, 15, 37, 38, 133, 135
Reception of light, 68, 81–5, 128–9
Rerum gestarum, 119
Reynolds, Sir Joshua, 12
Robbia, Luca della, 28, 39, 99
Rome, St. Peter's, 100, 124, 127
Ruccellai, Palla, 120

Seneca, 126, 131
Serapion, 96, 135
Sitedius, 65, 119
Socrates, 66, 68, 119
De statua, 22
Strabo, 132

Suetonius, 119
Suitability, 74

Tacitus, 119
Thalia, 91
Theataetus, 109
Timantes, 55, 78, 82, 128
Titedius Labeo, 119
Della tranquillità dell'animo, 17, 37, 120, 135
Trismegistus, Hermes, 65, 119
Turpilius, 65, 119

Uccello, Paolo, 30, 128, 135
Ulysses, 73, 78, 124, 126

Valentinian, 66, 119
Variety and copiousness, 23, 26-7, 75-6
Varro, 27, 66, 76, 120, 126

Vasari, 12, 29, 30, 37, 116, 120
Venus, 26, 74
Venus (star), 50
Verrine Orations, 119
Vespasiano da Bisticci, 125
Virgil, 54, 74, 85, 108, 125
Vision, process of, 45-9
Vitruvius, 15, 22, 73, 84, 109, 119, 130, 133
Vulcan, 75

'The well-known face', 93-4

Xenocrates, 65, 119
Xenophon, 68, 121

Zenodorus, 94, 134
Zephyrus, 81
Zeuxis, 64, 80, 82, 93, 128, 130, 134, 135